The Story of London

Stephen Porter

First published 2016

Amberley Publishing
The Hill, Stroud
Gloucestershire, GL5 4EP

www.amberley-books.com

British Library Cataloguing in Publication Data.
A catalogue record for this book is available from the British Library.

ISBN 978 1 4456 4585 8 (print)
ISBN 978 1 4456 4590 2 (ebook)

Typeset in 9.5pt on 12.5pt Sabon.
Typesetting and Origination by Amberley Publishing.
Printed in the UK.

Contents

1. A section of the Roman wall of the early third century was uncovered when Newgate Prison was demolished in 1903, and recorded by Philip Norman. (Stephen Porter)

Londinium

London was created by the Romans following the invasion of Britain by Claudius's army in AD 43. Julius Caesar's incursions in 55 BC and 54 BC had been short-lived, and no settlement had been formed on London's future site over the following decades, although the tribal societies of pre-conquest Britain had developed *oppida* at Colchester, Verulamium, close to the future St Albans, and Silchester, in Hampshire. But within a few years of the Claudian conquest a town came into being on the north bank of the Thames, at the river's lowest bridging point, which was known as Londinium. The name was not a Latin one, and perhaps derived from pre-Celtic elements which referred to a place at the navigable river. It was retained, in various forms, throughout the Anglo-Saxon period, and subsequently became standardised as London.

On the north side of the river the two low hills of Ludgate Hill and Cornhill, separated by the Walbrook, provided a suitable site for a settlement. The army may have established a camp on Cornhill soon after the invasion, and streets were laid out there by around AD 47. Across the Thames from Cornhill was a peninsula, or possibly an island, which projected into the river among the mudflats, and the two dry sites were connected by a bridge by around AD 50. The settlement which then grew up on its south side was to develop as the suburb of Southwark.

Londinium grew rapidly as a trading town, and by around AD 60 its population may have reached 10,000. A grid of streets was set out around a marketplace on Cornhill; the historian Tacitus described it as 'an important centre for business-men and merchandise'. The main street ran from east to west across the two hills and the Walbrook valley, continuing to the west along Newgate Street and becoming Watling Street, which connected Londinium with Verulamium and had a branch that led to Silchester, and to the east along the line of Fenchurch Street to Colchester. The street from the bridge continued northwards on the line of Bishopsgate and became

Ermine Street, connecting Londinium with York and Lincoln; across the bridge it ran through Southwark and on to Canterbury and Richborough. The steep descent to the river was terraced and landing places were formed and warehouses built, while on the south side of the river timber piling was used where necessary to raise the roadways above the marshy surface.

Development was abruptly halted by the revolt of Boudicca, the queen of the Iceni, in East Anglia. This erupted in AD 60 and continued into the following year. After her army had burnt Colchester the Romans prudently withdrew from Londinium: 'The inhabitants were allowed to accompany them. But those who stayed because they were women, or old, or attached to the place, were slaughtered by the enemy.' Boudicca's followers burnt both Londinium and Southwark and then moved north, torching Verulamium, before being defeated at a battle in the Midlands. Londinium's recovery initially was sluggish, but after ten years or so the town was rebuilt and again began to grow. During the last few decades of the first century it prospered, serving as an important port for the province and as the focus of its developing road network. It also had an important administrative role, with the procurator, who was the principal tax collector, based there, and that was enhanced when the headquarters of the governor of the province was moved to the town from Colchester. By the early second century its population may have been as high as 30,000 and Londinium was the province's most significant town. Its merchants traded not only with northern Europe but also with ports in the Mediterranean, from where imports included olive oil, wine and fish sauce; bronze lamps were brought in from Italy and emeralds in a necklace found at Cannon Street came from Egypt.

A forum and basilica constructed on the site of the market on Cornhill were soon replaced by a much grander complex which took thirty years to build. In around AD 70 a wooden amphitheatre was erected, on the site of Guildhall Yard, and public baths were built close to the river. A temple erected during the period was also west of the Walbrook, suggesting that building density on Cornhill prevented the construction of large complexes in that area. The amphitheatre was rebuilt in stone and to a larger plan in the early second century; it then had space for as many as 8,000 spectators.

The majority of houses, shops and workshops were built of timber and roofed with thatch; their water supply came from wells. Craftsmen using the workshops included goldsmiths, coppersmiths, leather workers (especially shoemakers), potters, enamellers and iron forgers. Fires occurred from time to time and a major blaze at some point in the years AD 125–30 destroyed buildings from Newgate Street in the west almost to the edge of the built-up area in the east. A fort covering twelve acres was constructed

in the Cripplegate area; it may have been built before the fire and was untouched by the conflagration, or its erection could have been prompted by the disaster to provide a secure base separate from the town's flammable buildings. It housed a garrison and possibly the governor's staff.

In the aftermath of the fire, and with changes in trading patterns, Londinium experienced a decline that lasted for much of the second century. Its public buildings were not only left unrepaired but in some cases were demolished completely, while the riverside embankments were neglected. The population may have fallen by as much as two-thirds after around AD 150, and some districts were all but abandoned. Political instability within the empire and struggles for power by rival claimants backed by sections of the army may have contributed to Londinium's malaise.

In the early third century a defensive wall was built to encircle the town, incorporating the Cripplegate fort. The wall was two miles long, nine feet thick and twenty-one feet high and enclosed 330 acres, with gates at Ludgate, Newgate, Bishopsgate and Aldgate; Cripplegate was the northern gate of the fort and Aldersgate was made later. The cemeteries lay outside the gates, following the customary Roman practice. Skeletal remains show that the citizens typically were of good physique and had an adequate diet, but only roughly one in ten were more than forty-five years old when they died.

Londinium experienced a relatively prosperous period during the third century, and large houses were built, floored with fine mosaics and decorated with wall paintings. The early third century saw the arrival in Britain of the cult of Mithras, an exclusively male cult which had originated in Persia before being adopted throughout much of the empire. A temple of Mithras was built close to the Walbrook in the 240s. Londinium contained a number of temples serving the various beliefs and cults from around the empire, which during the third century included Christianity, and in 313 the Edict of Milan permitted the practice of the faith without persecution.

Despite this prosperity, from roughly the middle of the third century further political upheavals and an increasing inability to prevent raids across the North Sea produced a growing insecurity. The defensive wall was extended along the riverside in the east as far west as Blackfriars to provide protection against the raiders, and bastions were added along its eastern side around 371–75. Londinium's administrative role was diminished as the province was divided, first into two provinces in the early third century and then into four around 300. A fall in the water level of the Thames made the loading and unloading of cargoes more difficult, even though the waterfront had been built further out. Patterns of overseas trade were changing, with Gaul and Germany becoming relatively more important as trade with the Mediterranean declined. Nevertheless, commerce continued throughout the

fourth century and there was new building work, including a large basilica in the east of the town, close to the wall.

As well as the military threat from outside the empire, the changing political situation within it affected Britain. On four occasions after 340 the army in Britain was deployed on the Continent to support rival forces and candidates for the imperial throne. In 407 Constantine III, proclaimed emperor in Britain, took the army to Gaul to repel an invasion by tribes from Germany and stabilise the Rhine frontier, and then to put down revolts in Spain. Thereafter, the situation in Britain was such that, according to the Byzantine historian Zosimus, it 'forced the inhabitants of Britain and some of the tribes in Gaul to secede from Roman rule and to be independent, obeying Roman laws no longer ... expelling the Roman officials and establishing whatever government they wished'. Paying taxes for an army which was no longer present and was unlikely to be replaced was futile, and without troops the Roman officials could not maintain their authority. In Italy the emperor Honorius was increasingly beleaguered, and in 410 the Visigoths sacked Rome. Neither Honorius nor Constantine could deal with the problems of provinces on the north-west edge of the empire, and in 410 Honorius advised the Britons that they should 'guard themselves'. The ending of Roman rule was followed by a decline in conditions within Londinium, which was gradually deserted during the fifth century.

Anglo-Saxon London

The raids which threatened Londinium developed into invasions by the Angles and Saxons. In 456 the Britons were defeated by a Saxon army at a major battle in Kent and they then 'fled to the stronghold of London'. But it could not be maintained as a refuge, for the line of the walls was too long to be defended by its small and steadily falling population. London was abandoned and the Roman provinces became a number of Anglo-Saxon kingdoms; the kingdom of Kent stretched as far as the Thames, with that of the East Saxons established north of the river and including the site of Londinium.

A part of the town was again occupied following the reconversion of England to Christianity, which began when the Pope sent a mission under the Benedictine monk Augustine in 597. A second group of monks followed in 601 and one of them, Mellitus, was consecrated by Augustine in 604 as bishop of the East Saxons with his seat at London. The cathedral which he founded, dedicated to St Paul, was probably on the hill overlooking the valley of the River Fleet, which became the site of the later cathedral buildings. But in 616 Mellitus was expelled by the pagan sons of Saebhert, king of the East Saxons, following his death. Only when Theodore of Tarsus, Archbishop of Canterbury from 669, consecrated Erkenwald as bishop around 675 was the see effectively re-established.

By the late seventh century, control of London had passed to the kingdom of Mercia; a later tradition held that Offa, king of Mercia from 757 to 796, had a palace in the vicinity of the modern Wood Street, within the Cripplegate fort. The area east of Wood Street did evolve as the administrative centre of the city: a guildhall was referred to in 1128 and a hall for public meetings was in existence to the east of Aldermanbury before the end of the twelfth century.

The historian Bede described the East Saxon capital at the time of Mellitus as being 'the city of London, which is ... an emporium for many nations who come to it by land and sea'. A grant of land near to the river made in 672–74

referred to 'the port of London, where ships come to land'. That settlement was not on the site of Londinium, but to its west. Known as Lundenwic, which means 'old trading settlement', this covered roughly 150 acres in an area centred on the modern Aldwych, between Kingsway and Trafalgar Square, and the Thames and Oxford Street. By 800 it had a population of roughly 4,000 and was a settlement of artisans as well as the traders, who had connections to the lower Rhine, the Meuse valley and northern France. The foreshore provided a landing place for ships and the bridge must have been partially ruined, if not completely collapsed, for it did not prevent seagoing vessels from reaching so far upstream.

Danish coastal raids became increasingly common during the early ninth century. In 842 'there was a great slaughter in London' and in 851 the Danes 'stormed Canterbury and London, and put to flight Beorhtwulf king of Mercia with his army'. The kingdom of Wessex had gained control of the south side of the Thames and put growing pressure on Mercia, which was also under attack from the Vikings. The Mercians were unable to prevent the Viking 'great army', which had landed in 865, from occupying London in 872; it may have remained in Danish hands in the following years. In 871 Alfred became king of Wessex and his principal task was to stem the encroachment of the Norsemen, which had seen the occupation of Northumbria and East Anglia, the loss of much of Mercia and incursions deep into Wessex itself. In 878 he defeated the Danish army at Edington in Wiltshire and in 886 his forces occupied London, which he then entrusted to his son-in-law Aethelred, ealdorman, or ruler, of the Mercians. Aethelred retained control of the city after Alfred died in 899 until his own death in 911.

During Aethelred's period in charge of London the inhabitants moved within the Roman walls of what was now known as Lundenburg, 'the fortified town', and Lundenwic was gradually abandoned. New streets were set out on Ludgate Hill and Cornhill; only those streets leading from the gates followed the Roman plan. Cheapside became the main east–west thoroughfare, and streets were laid out south of it, east of Bread Street and down to the river. A market space was set out in the late ninth century south of Cheapside and Poultry, its eastwards extension. East of the Walbrook, streets were built south of Eastcheap around Fish Street Hill, continuing to the Thames at Billingsgate. The bridge was repaired, or was rebuilt, and Southwark, probably unoccupied since the fifth century, revived and was first mentioned by name as one of the burhs established by Alfred. A jetty was built at Billingsgate around 1000 and the quay at Queenhithe saw considerable changes in the early eleventh century. Ships from London once again traded with the Mediterranean, as well as with the ports of northern France and Germany.

The city within the walls continued to develop, with new streets set out north of Cheapside in the tenth century, despite periodic epidemics and fires. Viking raids resumed in 980 and Londoners repelled attacks in 994, 1009 and in 1013, but later in 1013 they did submit. The period of warfare ended in 1016, when Cnut, son of Swein 'Forkbeard', King of Denmark, became king of the whole country. The wars had confirmed London's importance, militarily, politically and economically. From the tenth century it was England's largest and wealthiest town; in a levy imposed in 1018 it was to pay £10,500 while the rest of the country paid £72,000.

Cnut died in 1035 and his reign was followed by those of Harold Harefoot and Harthacnut. After Harthacnut's death in 1042, Edward the Confessor, Aethelred's seventh son, became king. He had spent twenty-five years in exile in the Norse duchy of Normandy, and Norman influences were a feature of his reign, although they were checked to a certain extent by a crisis in 1051–52, which culminated in Earl Godwine of Wessex and his sons gaining a strong position at the expense of the pro-Norman elements. Edward's reign was, in most other respects, peaceful and favourable for both internal and external trade, which benefited London, with its population of perhaps 15,000 by the middle of the eleventh century.

Edward instigated a major development by re-founding the Benedictine abbey of St Peter's at Westminster and rebuilding it on a grand scale. This stood on an island between two branches of the River Tyburn, which bifurcated before reaching the Thames. The site had the advantage of being near to London, but separate from it, and Edward also built a royal palace close to the abbey. With the abandonment of Lundenwic, the reoccupation of Lundenburg and the development of Southwark, London had consisted of two components; the development of a royal enclave at Westminster added a third. The new abbey church was dedicated on 28 December 1065, but the king was too ill to attend and he died a week later. He was buried in the church on 6 January and Earl Godwine's son Harold was crowned king there on the same day.

Harold's right to the crown was challenged, and although he defeated an invading army under his disaffected brother Tostig and Harald Hardrada, King of Norway, at the Battle of Stamford Bridge near York on 25 September, he was in turn defeated and killed by Duke William of Normandy's army, near Hastings on 14 October. The Normans then advanced towards London, but as they could not hope to force a crossing at the bridge, they carried out a wide encircling movement through Berkshire into Bedfordshire and Hertfordshire before occupying Westminster, where they prepared to attack the city. Opposition in London was ineffective and the Normans prevailed; William was crowned in Westminster Abbey on Christmas Day.

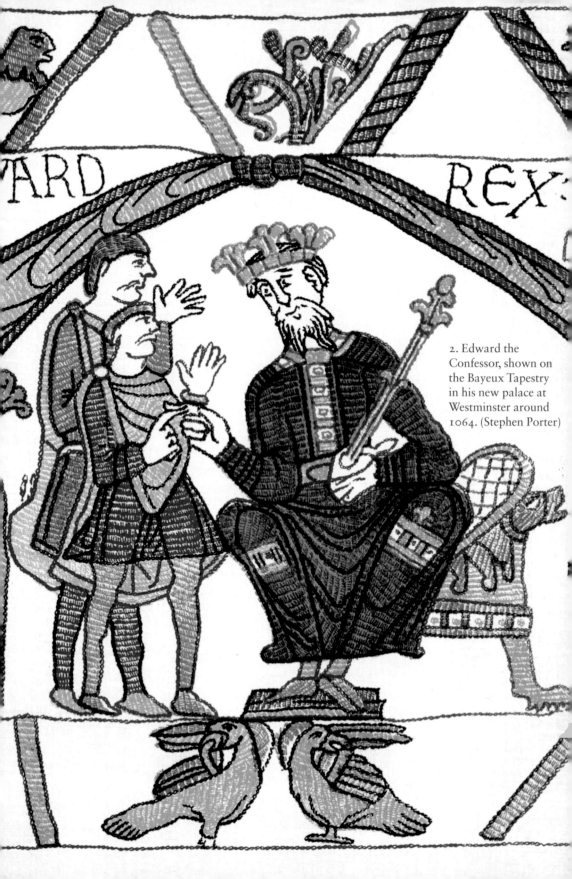

ARD ... REX

2. Edward the Confessor, shown on the Bayeux Tapestry in his new palace at Westminster around 1064. (Stephen Porter)

Medieval London

The Normans quickly built new fortifications in London. These were Baynard's Castle and Montfitchet's Tower, close together west of Ludgate, and an irregularly shaped enclosure within the south-east corner of the city walls, where a great stone keep, the White Tower, was begun by William the Conqueror in 1078 and completed during the reign of his son, William II (1087–1100). The White Tower became the principal building of the Tower of London, a castle to protect the city, a restraint upon the citizens and a royal palace. It also came to function as the state prison, a military arsenal and a safe deposit for bullion and the records of government and the courts.

The other major building works carried out under the Norman kings were the erection of Westminster Hall by William II and, also during his reign, the rebuilding of St Paul's Cathedral, destroyed by a fire in 1087, together with 'many other churches and the largest and noblest part of all the city'. The new cathedral was eventually finished in the early fourteenth century. The city also contained more than 100 churches and the dedications of some of them, to St Botolph and St Oláf, for example, show a pre-conquest origin, probably as private churches from which the parish structure evolved in the eleventh and twelfth centuries. In addition, according to William Fitzstephen's description of his native city in the twelfth century, almost all of the senior clergy had 'magnificent houses there, to which they resort, spending large sums of money'.

Fitzstephen described London as having 'abundant wealth, extensive commerce, great grandeur and magnificence', and its size and affluence, and the royal palaces at Westminster and the Tower, gave it a major role as a focus of political power. But Winchester, the chief city of Wessex, retained an important function as a royal centre, with its strategic position enhanced by the unification of England and Normandy in 1066. Only after the loss of Normandy in 1204 could London justly be described as the unrivalled capital of England.

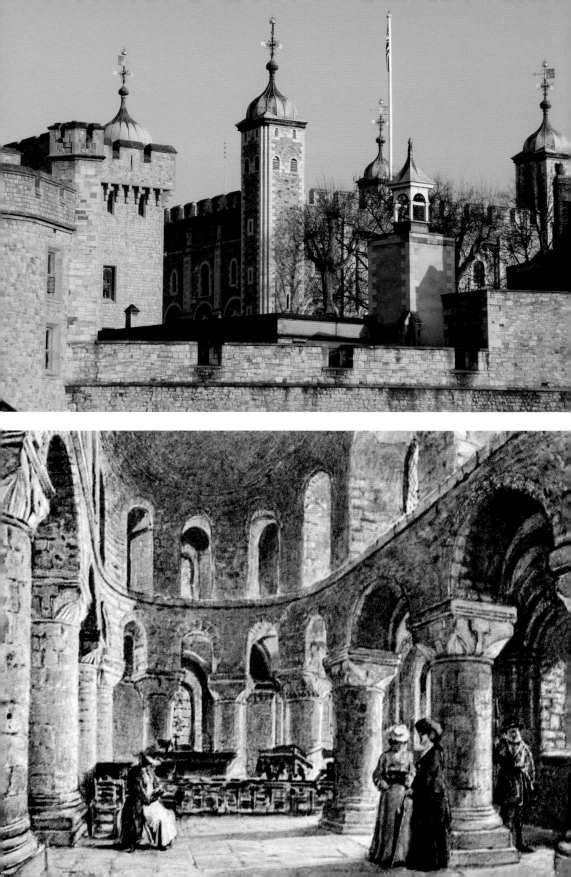

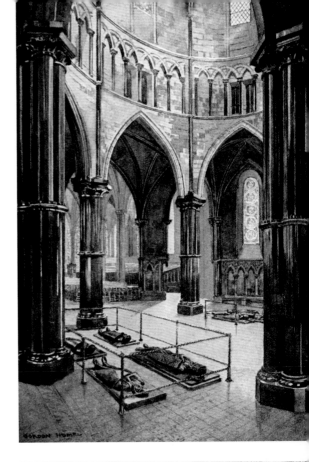

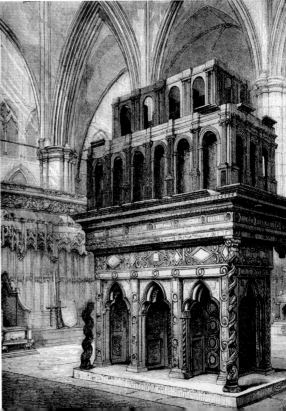

Opposite above: 3. The Tower of London from the west. The four turrets are those of the White Tower, which was begun in 1078. (Stephen Porter)

Opposite below: 4. The characteristic Norman Romanesque architecture survives in the chapel of St John, within the White Tower of the Tower of London. (Stephen Porter)

This page above: 5. The Order of Knights Templar built this circular church between Fleet Street and the Thames; it was dedicated in 1185. (Stephen Porter)

This page below: 6. Henry III's rebuilding of Westminster Abbey was associated with his patronage of the cult of Edward the Confessor, whose body was moved to a vault in a new chapel in 1269. (Stephen Porter)

7. The crypt of the Rose, a house between Laurence Pulteney Hill and Suffolk Lane that belonged to Sir John de Pulteney, who served as mayor in the 1330s. The crypt was destroyed in 1894. (Stephen Porter)

The city's privileges were set out in royal charters, and the citizens negotiated with the Crown on such matters as the right to trade within England free from tolls and the annual levy imposed upon the city. They attempted to fix the levy at no more than £300, which they achieved as a concession from kings in a weak political position, such as Stephen and John, while those firmly in control, such as Henry II, set it at more than £500. The post of staller, introduced by the Danes, was discontinued under the Normans, with two sheriffs, appointed by the Crown, deputed to collect the levy. By Fitzstephen's time the city was subdivided into twenty-four wards, where local courts were held under the direction of an alderman. The size of the wards reflected the density of occupation; Farringdon was the largest, containing Ludgate and Newgate, reflecting the sparser development in the western part of the city. In 1394 it was divided into two, and in 1550 Southwark became Bridge Ward Without, bringing the number of wards up to twenty-six.

The first mayor was Henry Fitz Ailwin, who was described as mayor in 1194 and held the post until his death in 1212. In a charter of 1215 King John conceded the principal of an elected mayor, who was chosen from among the aldermen at an annual gathering of the freemen (the term lord mayor came into use during the sixteenth century). The mayor was senior to

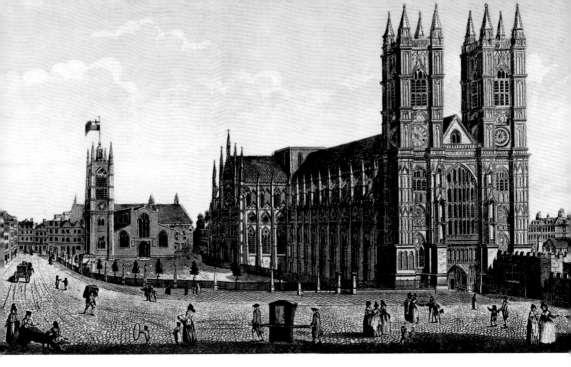

8. Westminster Abbey was rebuilt from 1245 under the patronage of Henry III; the towers at the west end were added in 1734–45. The adjoining church is St Margaret's, built between 1482 and 1523. (Stephen Porter)

the sheriffs; John also accepted that the sheriffs should be chosen by the city, not the Crown. And so by the end of his reign in 1216 London had become a self-governing city, with its principal officers chosen from among its own citizens. From those arrangements the Court of Aldermen had emerged as the city's ruling body, providing the agenda for the much larger Common Council, the legislative body, which had become an element in the city's government during the thirteenth century, and having the right of veto over its proceedings. Common Council was called and dissolved by the mayor and its members were elected by the Court of Common Hall, with the right to vote restricted to the freemen of the city. The guildhall was the meeting place of the Court of Aldermen and the Court of Common Council, and the place where elections were held.

Another element in city's administration was the craft and trade guilds, the earliest of which, the weavers and the bakers, were established in the mid-twelfth century. They became more numerous from the thirteenth century, until there were roughly sixty-five of them around 1300. They limited access to their trade, and so controlled the numbers entitled to work, by regulating apprenticeships and the journeymen; they also maintained the quality of the product and provided help for needy widows and children of deceased members. They came to be known as livery companies in the

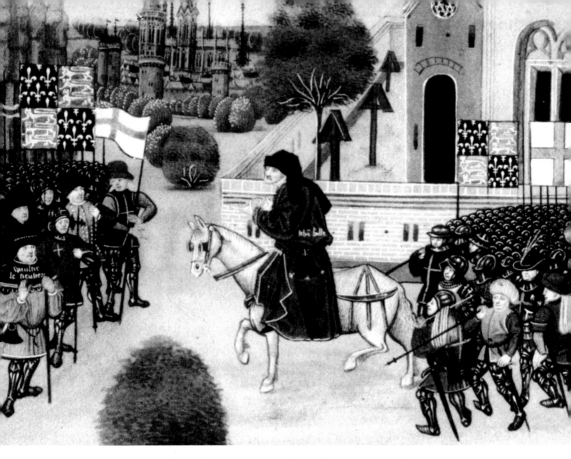

9. The preacher John Ball advocated social reform. Here he is preaching to the rebels during the Peasants' Revolt in 1381. (Stephen Porter)

fifteenth century and by then they had developed an important role, as their leaders became the powerful men in the city's administration.

The Crown occasionally intervened in London's affairs and it retained a strong presence in the city at the Tower. Henry III extended its area by enlarging the outer ward and created a new royal palace within the inner ward, and Edward I pushed the walled area even further out into the city; during his reign the Tower attained the size and form which it still retains. At Westminster, Henry III developed the cult of Edward the Confessor, who had been canonised by Pope Alexander IIIa in 1161, by rebuilding the abbey church, with a new tomb for the saint's remains, which were placed there in 1269. Edward's cult and shrine were primarily royal concerns; the Londoners' own especial saint was Thomas à Becket, Archbishop of Canterbury, following his murder by Henry II's knights in 1170 and canonisation in 1173. His shrine was in Canterbury, but he was born in Cheapside and a chapel dedicated to him was erected on the bridge, probably in the early thirteenth century, and rebuilt in 1384–97.

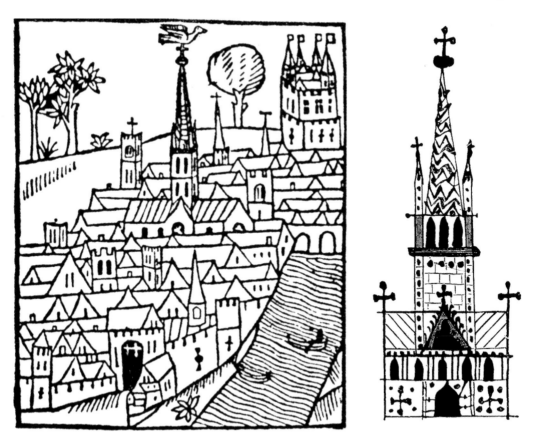

Above left: 10. A drawing of fifteenth-century London, with Ludgate in the foreground, the tower and spire of St Paul's Cathedral in the centre and the White Tower at the top. (Stephen Porter)

Above right: 11. St Paul's Cathedral, in a re-drawing of an early fourteenth-century manuscript. Its tall steeple was destroyed by a storm in 1561 and the building was burnt in the Great Fire in 1666. (Jonathan Reeve, JR329b11p385 13001350)

The pre-conquest bridge had been destroyed by a surge of water in 1091 and its replacement was damaged by fire in 1135, so a new timber bridge was built in 1163, overseen by Peter de Colechurch, a parish priest. The previous problems demonstrated the need for a more durable structure and so a stone bridge was built, between 1176 and 1212, under de Colechurch's direction. A gatehouse with a drawbridge was built at its south end and in 1426 a second, larger, gatehouse was added. At just over 300 yards long, it was by far the largest stone bridge in England. What made the bridge unusual, apart from its size, were the shops which lined the roadway on both sides, and it drew admiring comments from visitors for its structure and the richness of the goods for sale in its shops.

The bridge prevented seagoing vessels from sailing further upstream. In 1275 Edward I introduced a levy on wool, effectively initiating a national system of customs, and the quays on the north bank between the bridge and the Tower became the Legal Quays, where goods liable for customs duties were loaded and unloaded, and where a custom house was built around 1382. The quays were steadily enlarged and improved. Following a dispute between England and Flanders in the 1370s, Italian merchants and those from the Hanseatic League of north European ports had taken their place, and they operated through London. The Hanseatic merchants were based at the Steelyard, on the Thames. The Italian and north European merchants also took over some functions, such as the granting of loans, from the Jewish community, who suffered from persecution during the mid-thirteenth century and were expelled by Edward I in 1290.

London's trade prospered during the thirteenth century, with imports of Baltic grain, cloth from Flanders, furs from Russia, wine from Germany and increasingly, too, from Bordeaux following the uniting of Gascony to the English Crown in 1152. Luxury items such as spices, silks, gold, precious jewels and enamels were also imported. With the prosperity of overseas trade and the output of London's skilled artisans, the city's economy grew, as did its population, which may have risen in the twelfth century to around 40,000 and by 1300 it had reached roughly 80,000. Provisions were drawn from south-east England and beyond, and the water supply from wells was augmented by that from conduits. Other environmental matters were dealt with, such as the removal of refuse and waste, regulation of noxious trades and the prohibition of thatched roofs.

The fourteenth century saw a quite different demographic pattern. Poor harvests for several years before 1315 had led to high prices for foodstuffs, but it was the almost incessant rain during the summer and autumn of that year which caused a catastrophically bad harvest across much of northern Europe. The famine and epidemic lasted through the next two years and checked population growth. Subsequently, Edward III's decision in 1334 to assert his claim to the French throne by force began the Hundred Years War. The military campaigns were expensive to sustain and disruptive of London's trade.

Opposite above: 12. In the fourteenth and early fifteenth centuries London was the setting for jousts. The combatants are seen leaving the Tower, with a Gothic-style London in the background. (Stephen Porter)

Opposite below: 13. London in the mid-fifteenth century, looking upstream from the Tower, in a painting by John Fulleylove based upon a mid-fifteenth century illustration. (Stephen Porter)

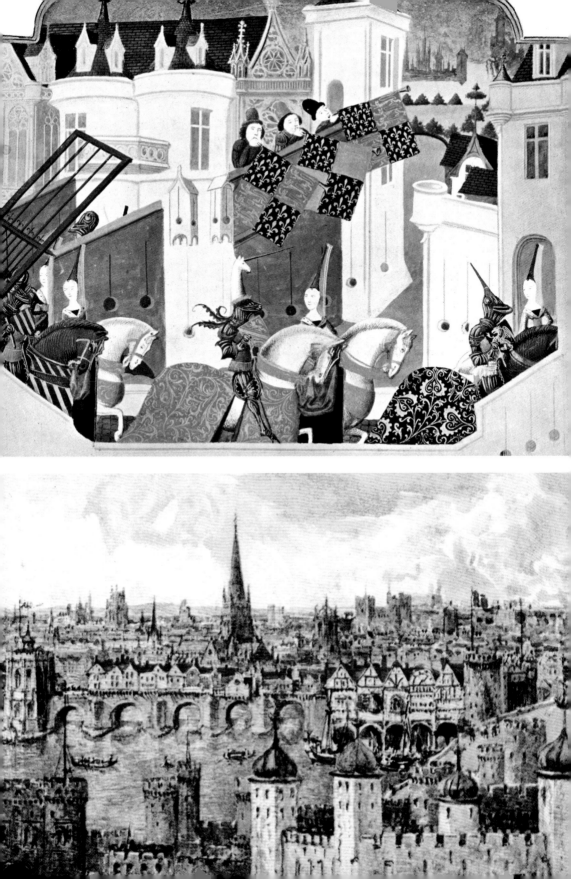

After the mid-fourteenth century London had a much smaller population from which taxes could be levied, for the Black Death reached the city in the autumn of 1348 and in less than a year killed at least one-third, and possibly half, of its inhabitants. During this 'grete pestylence at London' thousands were interred in three new burial grounds opened outside the walls. Monasteries were subsequently founded adjoining two of them, a Cistercian one at East Smithfield and a Carthusian priory at West Smithfield. Further plague epidemics followed; in 1361 plague killed roughly one-third of the depleted population, another in 1368 was less deadly, but in 1375 'a large number of Londoners, from among the wealthier and more eminent citizens, died in the pestilence'. London's population may have fallen below 40,000 and did not recover its former level before the mid-sixteenth century.

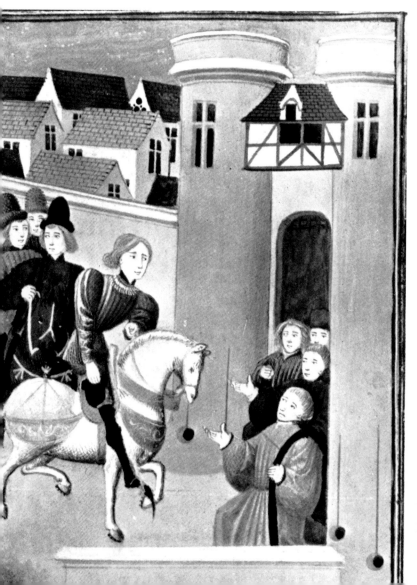

14. Henry Bolingbroke, Earl of Derby, arriving at London in 1399 to take control of the city prior to deposing Richard II and gaining the throne as Henry IV. (Stephen Porter)

A period of political turmoil followed the Black Death, both nationally and within London, culminating in the Peasants' Revolt in 1381. Only after the crisis which saw Richard II deposed in 1399 by Henry Bolingbroke, who took the throne as Henry IV, did the city's elite again hold unchallenged control and after his accession relations with the Crown improved. A relatively stable period followed. London's smaller population was advantageous for wage-earners and there were no serious food shortages. A municipal granary was erected at Leadenhall in 1455 and the City also supervised the market at Blackwell Hall, where cloth brought to London was sold. Cloth became England's most valuable export commodity as its cloth-making industry developed rapidly, with an overall rise in exports during the second half of the century from 5,000 to 160,000 cloths per year. The trade increasingly was in the hands of London merchants, and by the mid-sixteenth century 89 per cent of cloth was exported through the city.

By the fifteenth century London's leaders were drawn from the livery companies. They had confidence and wealth, building halls for their

15. Since the coronation of Harold II in 1066, English monarchs have been crowned in Westminster Abbey. The coronation of Henry IV took place there in October 1399. (Stephen Porter)

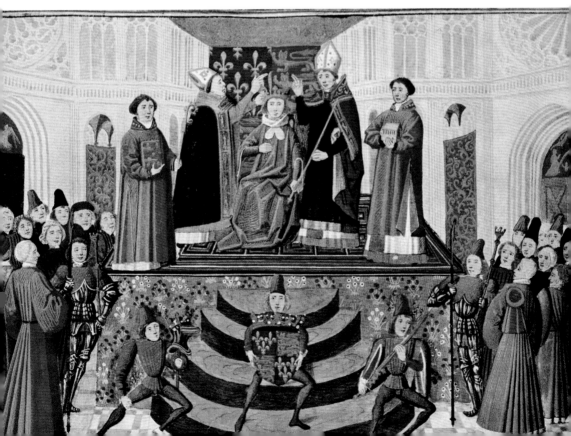

companies and a new guildhall for their city, the largest guildhall in medieval England. Begun in 1411, it took almost twenty years to complete. Through their livery company or directly, Londoners donated some of their wealth for charitable purposes, to the thirty or so monastic houses as well as to the religious fraternities which were attached to them and to the parishes. From such donations roughly a quarter of the property in the city came to be held by the monasteries, providing them with rental income. Almshouses for the elderly and writing schools, grammar schools and music schools for the young were established. Literacy extended beyond the wealthy mercantile classes and the livery companies came to require a basic level of education for would-be apprentices; probably more than 50 per cent of the adult male population and a lower, but significant, proportion of women were literate. Women were active economically and were permitted to take up the freedom of the city, and so they enrolled as apprentices and traded alone, and widows could continue their husband's business.

The literate Londoners provided a market for printed books, which were being imported into the city before William Caxton set up his printing press in Westminster in 1476. Wynkyn de Worde took over Caxton's business after his death in 1492 and in 1500–01 he moved to premises in Fleet Street. Other printers followed, beginning the district's long connection with the printing trade.

Above left: 16. A taverner greeting a guest, depicted in William Caxton's *The Game and Playe of the Chesse* from around 1474. (Stephen Porter)

Above right: 17. A domestic scene in a bedchamber, drawn in the mid-fifteenth century for John Lydgate's Life of St Edmund and showing the aftermath of the birth. (Stephen Porter)

The stability of the fifteenth century was disturbed occasionally by violent episodes, with Jack Cade's rebellion in 1450, and the Wars of the Roses, in which a Lancastrian force besieged in the Tower in 1460. London was, broadly speaking, more inclined to support the Yorkist cause rather than the Lancastrian one and had good relations with Edward IV, who took the throne in 1471, but not with Richard III, who succeeded him in 1483. During the dynastic quarrels the Tower was the scene of the violent deaths of Henry VI, Edward IV's brother the Duke of Clarence, and, most probably, his sons, Edward V and the Duke of York. With the defeat and death of Richard III at the Battle of Bosworth in August 1485 the Plantagenet dynasty came to an end. Henry Tudor then occupied London and was crowned Henry VII in Westminster Abbey on 30 October.

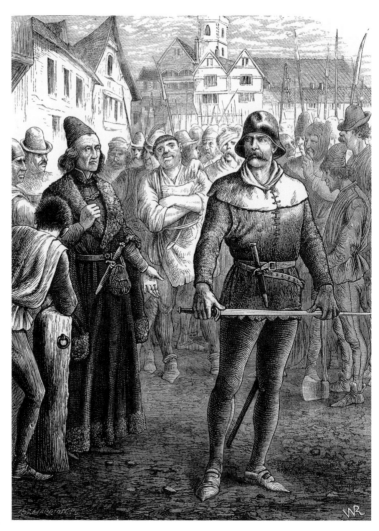

18. The imagined confrontation in 1450 between Jack Cade and Lord Saye, the Lord Treasurer, before Saye's trial and execution. Shakespeare set the scene in Smithfield, and it was depicted by William Ralston in 1884. (Stephen Porter)

Tudor and Jacobean London

Soon after the arrival of Henry VII's troops in the city, London was struck with a deadly and hitherto unknown disease. Probably a viral infection, it became known as 'the sweat' and was feared not only because of the high mortality rate, with 'scarcely one in a hundred' of those who contracted the disease surviving, but also because its victims died quickly, generally within twenty-four hours. Whereas the plague was thought of as mostly afflicting the poor, because the well-to-do took evasive action and left built-up areas, the sweat struck both the prosperous and the poor.

Severe epidemics of both the sweat and plague occurred intermittently through the fifteenth and early sixteenth centuries. An epidemic in 1498 carried off perhaps 10,000 people in London, the sweat returned in 1508–09 and during a 'great plague' in 1513 the daily death toll reached as high as 300 to 400. In the summer of 1517 another outbreak of the sweat was swiftly followed by a plague epidemic. Such eruptions prompted the introduction of measures designed to prevent the spread of diseases during an epidemic and to provide for the sick during their illness. Although the first such steps were taken in 1518, a codification of the orders for London was not issued until 1583. That was twenty years after the worst plague outbreak in the capital during the Tudor era in 1563, when 23,660 died, 85 per cent of them from plague, or roughly one-fifth of the population.

Despite the death toll during such outbreaks, and the high mortality levels during non-epidemic years, London's population continued to grow. Having taken two centuries to reach its pre-Black Death level, it then surged ahead relentlessly during the late sixteenth and early seventeenth centuries. The number of inhabitants rose from roughly 80,000 in 1550 to 200,000 in 1600 and perhaps 260,000 by 1625. That growth came to be a major concern to the government. It feared the threat to public health, for polluted air and a foul environment were thought to be among the causes of disease, exacerbated by overcrowding in such a large city. Another concern was the

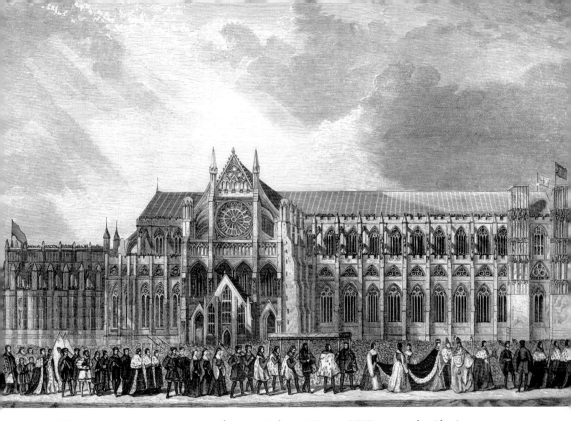

19. The coronation procession of Anne Boleyn, Henry VIII's second wife, in 1533, shown passing Westminster Abbey. From a drawing by David Roberts. (Jonathan Reeve, JR968b42p404 15001600)

rising number of poor people, which placed a strain on the system of poor relief and raised the spectre of social instability and unrest. The problems of the ever-expanding suburbs with 'filthy cottages', overcrowded tenements and rubbish dumps could not be ignored. The population increase had led to rapid and sometimes shoddy building, the adaptation of outbuildings to provide living space, the infilling of spaces within the city and the subdivision of houses. To curb the city's growth, a proclamation was issued in 1580 which prohibited new building and ordered that a house should be occupied by only one family, but this and subsequent orders were futile. London's growth was inexorable.

Families, apprentices and journeymen lived cheek-by-jowl in overcrowded accommodation, where privacy was a rare commodity, and warmth and security were perhaps greater priorities. Beds were placed not only in bedchambers but in any other available room or space, rooms were interconnected so that a bedchamber often provided a passageway to a room beyond, and children and servants were likely to share a bed with the husband or wife when there was an opportunity to do so. Privacy in

20. Henry VII's chapel in Westminster Abbey was completed after his death in 1509 and contains his tomb, with his queen, Elizabeth of York, and other royal tombs added later. This painting is by John Fulleylove. (Stephen Porter)

21. The livery companies were a major force in London's economy and administration. This painting, after Hans Holbein, depicts Henry VIII's grant of a charter to the Barber-Surgeons' Company in 1540. (Stephen Porter)

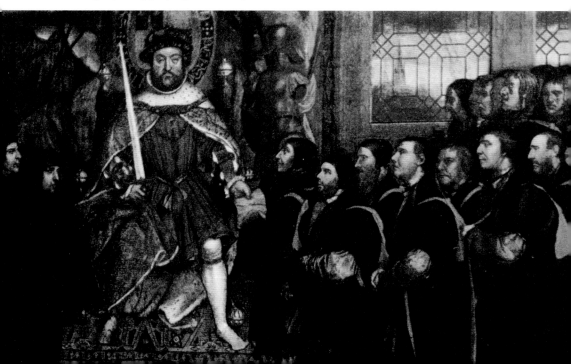

bed could be obtained only behind the bed-curtains, for those who could afford them. As the winters grew distinctly colder towards the end of the century, warmth would have overridden other considerations when sleeping arrangements were made.

In contrast to the scruffy and disreputable suburbs, the centre of the city contained timber-built houses of three and four storeys, roofed with tiles, but the frontages lacked uniformity, which came to be perceived as a shortcoming as tastes changed. A proclamation issued in 1605 attempted to improve the city's appearance by ordering that the fronts of houses should be of brick or stone and that 'the forefront thereof in every respect shall be made of that uniforme order and forme, as shall be prescribed unto them for that Streete'. That could be applied only to new or rebuilt houses, and so this change envisaged would take time to achieve. In any case, enforcement of all such environmental policies was hindered by the refusal of the City's government to expand its boundaries, and so while the area governed by the mayor and aldermen was closely regulated, the built-up area beyond was administered by the Middlesex and Surrey justices of the peace, with less authority and fewer resources in larger parishes. In the mid-sixteenth century 75 per cent of Londoners lived in the City, but the proportion fell as the population increased, and by 1700 it was only 25 per cent.

The authorities did not face a famine crisis when harvests were deficient and only occasionally were they troubled by protests against high prices, for population growth did not produce food shortages. Supplies kept pace with the city's expansion and were drawn from a wide area of England, and increasingly from Wales and Scotland, too. Market gardens were developed around the city from the late sixteenth century, providing its fruit and vegetables, and by 1617 they were said to employ 'thowsands of poore people'. The markets were regulated and the aldermen intervened when necessary to limit price increases. Water supplies were augmented, most notably with the opening of the New River in 1613, which brought water from Hertfordshire to Clerkenwell.

London's growth was fuelled largely by those attracted to the city from the provinces, for economic reasons. The livery companies had a near monopoly on the control of skilled labour, but they came under scrutiny in the late fifteenth and early sixteenth centuries, and had to present their regulations to the City for inspection and modification. Moreover, Parliament acted in the 1530s to remove restrictive practices by the companies, by fixing the fees payable by apprentices and prohibiting surcharges on their entrance fees, and so stopping the practice of limiting access to a trade by charging high fees. It also banned the custom of imposing an oath on men at the end of their apprenticeships by which they undertook never to set up shops, and

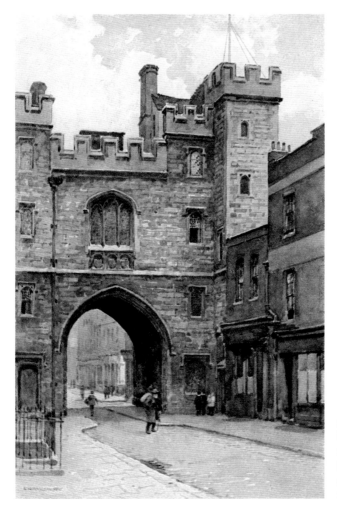

22. The gatehouse of the inner precinct of the Priory of St John of Jerusalem in Clerkenwell, founded around 1144, was built in 1504. (Stephen Porter)

so be competitors for the established figures in the trade. Those measures removed a potential restriction on the labour supply and the size of the livery companies and so London's economy was able to respond when there was a boom during the mid-century, especially in the textile trades.

Others were attracted to London from the Continent, and about 3,000 'strangers' lived in the city in 1500. Although their communities were small, they attracted resentment from time to time. There were anti-Italian flare-ups in 1456 and 1457, attacks on the Steelyard in 1462 and 1494, and a more serious riot in 1517, directed against the Flemish community, which came to be known as Evil May Day. Yet no similar anti-immigrant riot occurred thereafter, even though anxiety about the numbers of strangers prompted the city authorities and the government to organise enumerations. At a count taken in 1573 the city contained 7,143 strangers, which was a small

proportion of the whole population. The Dutch and Flemish community was settled chiefly east of the Tower and in Southwark, and other incomers came from France and Germany. During the second half of the sixteenth century religious refugees seeking asylum from persecution in the Low Countries and France came to form a significant proportion of the incomers. But London's prosperous and expanding economy provided a strong economic motive, with roughly a third of those recorded in 1573 stating 'that their coming hither was onlie to seeke woorke for their livinge'.

The city contained a range of manufacturing and service trades, skilled and semi-skilled workers, and wholesalers and retailers, who were described by the historian of London John Stow in 1598 as 'mercers, vintners, haberdashers, ironmongers, milliners, and all such as sell wares growing or made beyond the seas'. The merchants met in the open in Lombard Street until the completion of the Royal Exchange, in 1568, provided a place for them to trade, gather news and exchange opinions.

Overseas trade was expanding, along both the long-standing routes with northern Europe and Iberia and those to the developing markets in the

23. The Great Hall in the Charterhouse, a courtyard house built by Sir Edward North in 1546, incorporating parts of the Carthusian priory established on the site in 1371 and closed in 1538. (Stephen Porter)

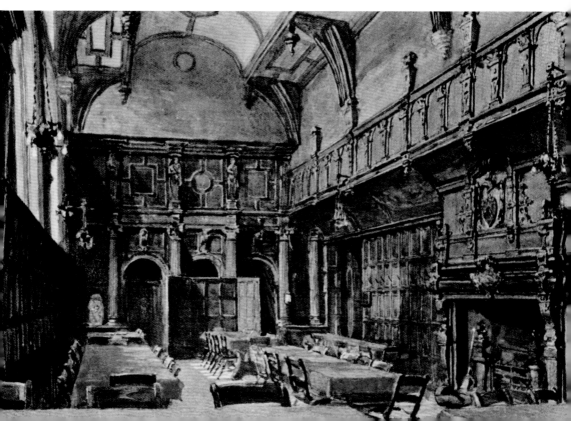

Americas, the Indian Ocean and the East Indies. Between 1555 and 1609 trading companies were formed for the commerce with the new regions: the Muscovy Company, the Eastland Company (for trade with Scandinavia and the Baltic), the Turkey Company, the Venice Company (the Turkey and Venice companies became the Levant Company in 1592), the East India Company and the Virginia Company. The Barbary Company was established in 1585 for trade with Morocco, but was dissolved twelve years later. The range of goods imported steadily widened, with pepper, currants, spices, silk, cotton, indigo, calico, dyes and sugar being brought in. Wine imports rose fivefold between 1563 and 1620 and as tobacco increased in popularity it became one of the more valuable imports. By the end of the sixteenth century London handled roughly 80 per cent of England's imports and exports.

Among the forces driving the city's economy was the presence of the royal court at Westminster Palace, until a fire there in 1512, and from 1529 at Whitehall Palace, which became the principal royal residence. The sittings of Parliament were more frequent from the reign of Henry VIII and continued to be held in Westminster, as did those of the courts of law. The aristocracy and the country gentry began to bring their families with them on their visits to London, for the meetings of Parliament or for social and business reasons, and to stay longer, producing a growing market for suitable accommodation and fashionable luxury goods, and business for the steadily developing professions.

In the 1520s Henry VIII's concerns over his lack of a male heir led to his seeking an annulment of his marriage to Katherine of Aragon. The Pope was unable to oblige and Henry's solution was to break from the papacy and make himself head of the English Church. Having achieved that, the king then expelled the monastic orders, dissolved the religious houses and their hospitals, and re-appropriated their lands and buildings. Most monks acquiesced, but members of the Carthusian order did not. The prior of the London Charterhouse, John Houghton, was executed in May 1535, together with the priors of Beauvale and Axholme. By 1540 ten monks and six lay brothers of the London Charterhouse had been executed or had died in prison, but no other order followed their example. The monastic property that was then disposed of included roughly one-third of properties within the city walls. Their sale released those houses onto the market, while the sites of the monasteries themselves were generally converted to grand houses by the wealthy. Among the exceptions was the Greyfriars in Newgate Street, which was given to the corporation. The grant of the Greyfriars was confirmed by Edward VI when he established Christ's Hospital there, for 'poor fatherless children'. Also presented to the city were St Thomas's Hospital, Bridewell

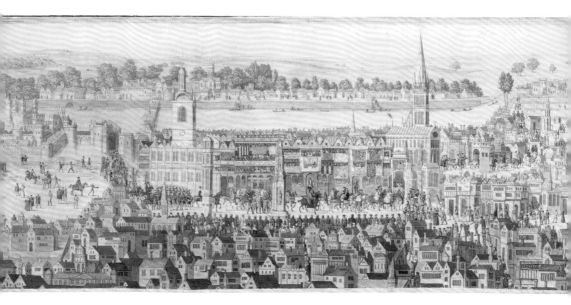

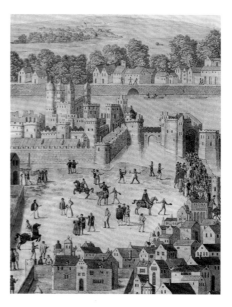

Above: 24. The coronation procession of Edward VI from the Tower to Westminster in 1547 is shown processing along Cheapside. This copy was made by Samuel Hieronymus Grimm (1733–94). (The Society of Antiquaries of London)

Right: 25. Detail from above illustration highlighting people relaxing on Tower Hill, as the procession streams out of the Tower. (The Society of Antiquaries of London)

Palace, which came to be used as a prison and workhouse, and a school for orphans and young criminals, and Bethlehem Hospital, which from 1377 had taken care of the insane and was continued as a mental asylum, generally known as Bedlam. But the chapel of Thomas à Becket on the bridge was demolished in 1553. Coincidentally, during the 1530s the ecclesiastical palaces which lined the Strand were acquired by members of the aristocracy and leading courtiers.

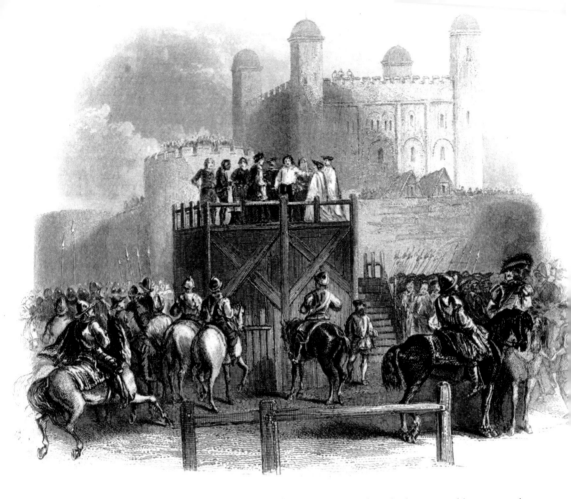

26. Tower Hill was the site of executions of prominent people, which attracted large crowds. This nineteenth-century illustration shows the execution of Lord Guildford Dudley in 1554. (Stephen Porter)

The redistribution of property could not be reversed during the reign of Mary Tudor (1553–58), when England returned to the Catholic faith and Protestants were persecuted. Between 1555 and Mary's death in November 1558, 283 people were burnt, seventy-eight of them in London, of whom fifty-six were executed in Smithfield. Although only roughly a fifth of the Protestant martyrs were burnt there, 'the fires of Smithfield' came to symbolise those burnt to death for their faith during Mary's reign. Mary's sister Elizabeth succeeded her and reversed these religious policies; Protestantism was restored and became firmly established during her long reign, until her death in 1603.

The religious debates extended to the level of charitable giving, with Catholic writers claiming that it had been adversely affected by the Reformation. In fact, the pace of donations increased, with contributions

and bequests to support the poor and elderly. They included funeral doles, collections for specific charitable needs and formal giving through the establishment of charities, such as those for the distribution of bread or the founding of schools and almshouses. Endowments were received from Londoners as well as those who had left the capital and become country gentry, who continued to establish and support charities in the city where they had made their fortunes. The most spectacular charity, for its scale and setting, was the almshouse for eighty men and school for forty boys established by Thomas Sutton in 1611 in the mansion built on the site of the Carthusian priory. Poor relief was also administered through the parishes, with a rate levied from householders for the purpose, a practice which was adopted by the government as a policy in 1572. The Poor Law arrangements were confirmed by legislation in 1598 and 1601.

Yet not everyone was happy with the level of giving and Stow complained that the citizens were now spending their money for show and pleasure. His comment referred to a growing enjoyment of prosperity and leisure. The citizens turned out in large numbers to watch the annual procession celebrating the inauguration of a new mayor. In the fifteenth century the mayors had taken a barge to Westminster to swear their oath of office, and during the sixteenth century that developed into a numerous and colourful armada of boats, with the mayor returning to the Guildhall in a procession that contained exotic animals, floats and a variety of entertainers. Another popular annual event was Bartholomew Fair in Smithfield, which lasted for three days in August. It combined a range of entertainments, such as puppeteers, conjurers, actors, balladeers, wrestlers, tightrope-walkers and fire-eaters, with trading, especially in cloth, leather, pewter, livestock, and butter and cheese. It was followed in early September by Southwark Fair, also a three-day event, which had been held from at least as early as the 1440s.

More regular entertainments included archery, dancing, music, bell-ringing and football, and watching cockfighting, animal-baiting and plays. Londoners most often went to Bankside, on the south side of the river, for their recreation. Until the mid-sixteenth century the district attracted attention chiefly because of its brothels, but it then became increasingly popular for its bull- and bear-baiting, in two arenas, and then its theatres. The earliest purpose-built playhouse was erected in Whitechapel in 1567 and others followed, in Shoreditch, Newington Butts, Clerkenwell and Bankside, and later indoor theatres at Blackfriars and in Drury Lane. Shakespeare was associated through his company, the Chamberlain's Men (the King's Men following James I's accession in 1603), with the Globe, which was erected in Shoreditch in 1595 and was dismantled and reassembled on Bankside, where it reopened in 1599. Plays ran for only a few performances and so

27. The crowded buildings of Tudor London are depicted around 1585, showing the City, between the Strand and St Katherine's, with Southwark in the foreground. (Stephen Porter)

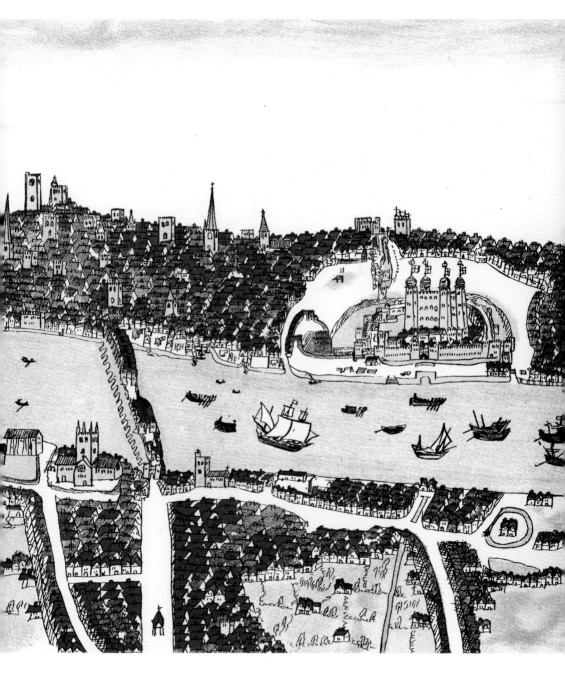

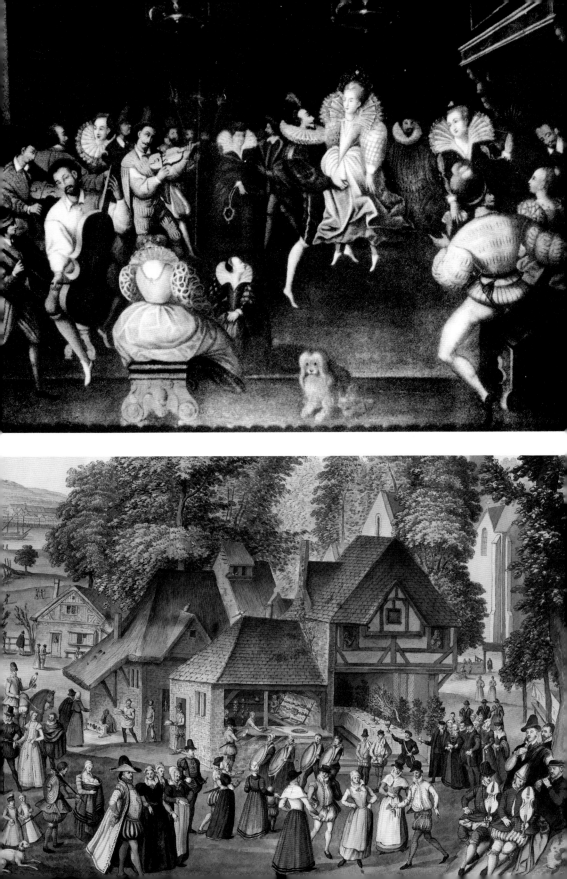

writers needed to produce a steady flow of new material. The audiences were drawn from a wide social range and probably numbered 21,000 per week by the early seventeenth century, when three playhouses and two hall theatres were open.

The theatres also attracted criticism, however. The Puritans, who were increasingly prominent in the city, found them repugnant on moral grounds, and both national and civic governments saw them as a risk to public health. Theatres were closed during plague epidemics, which occurred in 1592–93, the worst since 1563; in 1603, in the early months of James I's reign; and in 1625, soon after his son Charles had come to the throne. The outbreaks in

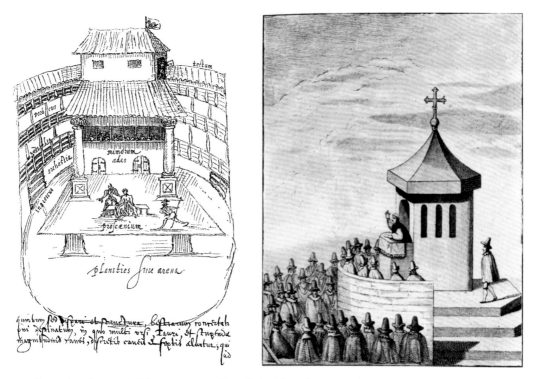

Opposite above: 28. The court contributed significantly to London's economy. Here Queen Elizabeth is dancing with the Earl of Leicester, her favourite; the artist is unknown. (Stephen Porter)

Opposite below: 29. At a feast at Bermondsey around 1570 musicians accompany the dancers, food is being prepared in the building and tables are set for the meal. The painting by Joris Hoefnagel was copied by Samuel Hieronymus Grimm. (The Society of Antiquaries of London)

Above left: 30. The interior of the Swan Theatre on Bankside, built in 1595 and sketched by Johannes de Witt in the following year. This is a copy of his sketch. (Stephen Porter)

Above right: 31. Paul's Cross was an open-air pulpit close to St Paul's Cathedral; sermons there attracted large congregations. The cross was demolished in 1643. (Stephen Porter)

1603 and 1625 each killed roughly one-fifth of London's population, but in both cases it returned to its pre-plague level within two years, because of the numbers drawn in to replace those who had died. Neither such devastating epidemics nor government policy on building checked the city's growth, which emphasised its economic power and unassailable position as the country's dominant city.

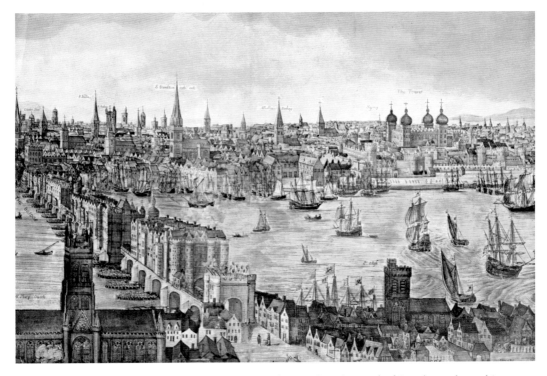

32. Claes Visscher's view of 1616 shows London Bridge, the Pool of London, where ships loaded and unloaded their cargoes, and the densely packed buildings between the bridge and the Tower. (Stephen Porter)

Civil War, Plague and Fire

Relations between London and the Crown were occasionally strained, but not to breaking point. Rebellions by Sir Thomas Wyatt in 1554 and the Earl of Essex in 1601 had not been supported by the citizens or their rulers. But by the early 1640s, the capital had developed a number of grievances against the government. The City's senior figures were unhappy with Charles I's policy of ruling through the Privy Council without calling Parliament, support for privileged concessionaires of patents and licences, and trades being organised separately from the supervision of the livery companies. The plantation of Ulster after 1608 had included considerable investment from London, through the City of London joint stock company and by the livery companies. An acrimonious dispute with the Crown over the management of the plantation culminated in the City's forfeiture of its Irish lands and a fine. A further challenge to the City was the establishment in 1636 of the New Corporation of the Suburbs, which it saw as a potential rival administration to the Court of Aldermen. The citizens were unsettled by the effects of the economic recession and William Laud's high church policies, initially as Bishop of London and, from 1633, as Archbishop of Canterbury.

During the crisis which followed the king's attempt to impose the Book of Common Prayer on the Scots and the two Bishops' Wars which ensued in 1639 and 1640, many Londoners aligned with Parliament, which the king had eventually called after an interval of eleven years. Londoners attacked the archbishop's palace at Lambeth and turned out in their thousands at Westminster to demonstrate against the king's ministers. In 1641 an enormous crowd watched the execution on Tower Hill of the Earl of Strafford, Charles's leading advisor. In January 1642 the king's attempt to arrest his leading opponents was thwarted and they took refuge in the City. When he went to Guildhall to demand that they be handed over he was rebuffed and was heckled in the streets by the citizens. He then left London and by the summer the country had descended into civil war. By then the

33. From 1529 Whitehall Palace became the principal palace of the Tudor and Stuart monarchies. The Banqueting House, added during the reign of James I, is the only part to have survived. (Stephen Porter)

pro-Royalist aldermen, including the lord mayor, had been displaced and those who supported the parliamentary leadership were appointed. The citizens acquiesced and by the time that the war began Guildhall was aligned with Parliament.

The Royalists' first objective in the autumn of 1642 was to capture London, or at least intimidate its citizens to such an extent that they permitted the king to return. But in mid-November his army was blocked at Turnham Green by a Parliamentarian army that included regiments of the London militia. In the following spring the city was encircled by earthwork fortifications, built by thousands of citizens in what was a major achievement in terms of effort, organisation and cohesion.

The Londoners continued to support the Parliamentarian war effort, despite high taxation, labour shortages as men joined the forces, losses of merchant ships to Royalist privateers, the absence of the wealthy courtiers and their households, and an influx of displaced people who took refuge in the city. Londoners also experienced discomfort because of a shortage of fuel when the Royalists controlled the coalfields around the rivers Tyne and

Wear, and Parliament's ships blockaded the ports to prevent the coal being shipped out. Only when the Scots joined the war on Parliament's side in 1644 and captured Newcastle were supplies resumed. But the war generated business too, and London benefited from the presence of Parliament, its role as the headquarters of Parliamentarian administration and by supplying the armies.

London did not support the Royalist cause in the Second Civil War in 1648, nor in the political crisis that culminated in the execution of the king and the abolition of the monarchy and the House of Lords in 1649. The organisation of the Church, too, was abolished and an attempt to impose a Presbyterian structure was only partially successful in London. The Protestant dissenters who had attracted growing support before the war now achieved freedom of worship, a policy that was maintained by the republican governments after 1649, with the Jews formally readmitted to the country in 1656. But that toleration did not extend to Roman Catholics.

The collapse of the Church's authority in 1642 saw the breakdown of censorship of publications and a veritable explosion of publishing followed: the London bookseller George Thomason acquired 24 titles in 1640, 721 in 1641 and 2,134 in 1642. With the new intellectual freedom came plans for reform, including proposals for the establishment of a university in London, but they were not taken further. Lectures in non-classical subjects had been delivered at Gresham College since its establishment in 1597, and its rooms were the meeting place for the Royal Society, which developed from the intellectual ferment of the 1640s and 1650s, receiving its first royal charter in 1662, after the restoration of the monarchy.

The economic revival that followed the Civil War was partly stimulated by the Navigation Acts of 1651 and 1660, which required that imports to England must be carried in English vessels or those of the country of origin. London's merchants were the chief beneficiaries of the policy. Trade continued to increase despite three wars with the Dutch, the chief carrying nation, between 1652 and 1674. Both exports and imports increased during the second half of the century, but the re-export trade expanded at a far greater rate and became an important element in London's economy. Another change in the structure of the economy was a growth in employment in domestic service, so that a growing proportion of the incomers during the second half of the century were young women, while the numbers of young men taking apprenticeships in crafts regulated by the livery companies began to wane. The city continued to grow and, with 575,000 inhabitants by 1700, became the largest city in Europe. As the national population was no longer increasing, the proportion of the total living in the metropolis rose to over 11 per cent by the end of the seventeenth century.

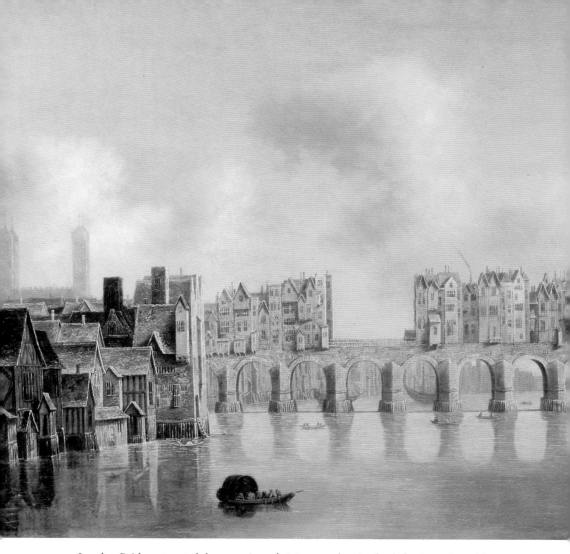

34. London Bridge attracted the attention of visitors to the city, both for its scale and because of the shops which stood on it. It was painted by Claude de Jongh around 1632. (Yale Center for British Art, Paul Mellon Fund)

That growth came despite two major disasters in the 1660s. London had not experienced a serious plague epidemic since 1636 and the last major outbreak was in 1625. It seemed that the policies to prevent the disease reaching England were effective, especially naval quarantine. But the early signs of an outbreak in London in the closing months of 1664 heralded the city's most deadly plague epidemic. Those who could leave the stricken city did so, but many did not have that option. Almost 100,000 deaths were recorded in London in 1665, 69,000 attributed to plague, although the number of plague deaths was almost certainly understated. This represented roughly 20 per cent of the population and the number of burials was

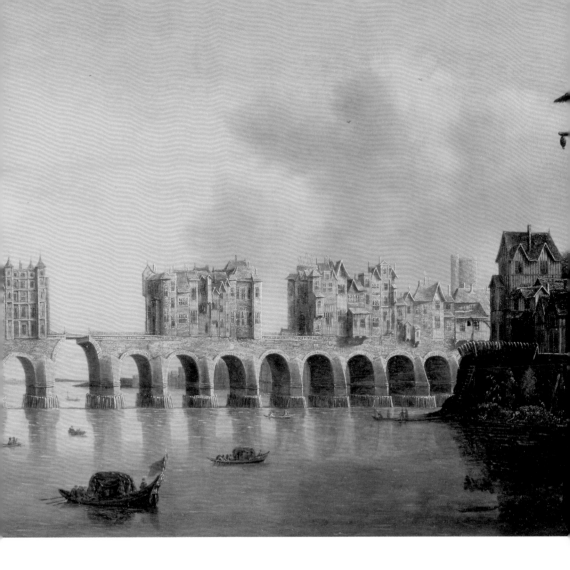

almost six times the annual average. Yet the losses were swiftly replaced, for incomers were not deterred by the possibility that the disease would strike again, and they were correct, for the Great Plague of 1665 was the last plague epidemic in London.

The second disaster was the Great Fire, which began early on the morning of Sunday 2 September 1666. It spread rapidly and extensively, partly because of a howling gale blowing from the estuary and partly because of the failure to tackle the blaze in its early stages by demolishing nearby buildings. Only when the wind dropped on the following Wednesday could the fires be extinguished and by then they had consumed four-fifths of the City, from

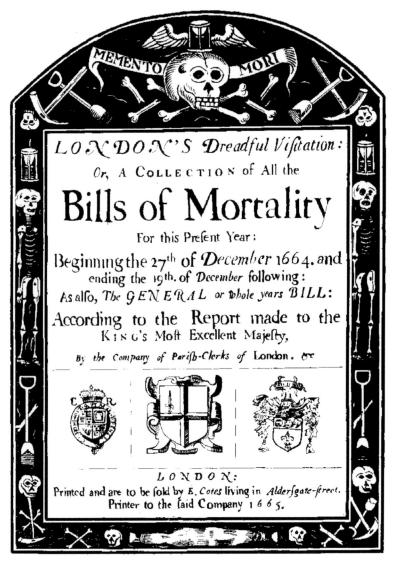

LONDON'S Dreadful Visitation:

Or, A COLLECTION of All the

Bills of Mortality

For this Present Year:

Beginning the 27th of *December* 1664. and ending the 19th. of *December* following:

As also, The *GENERAL* or *whole years BILL:*

According to the Report made to the KING's Most Excellent Majesty,

By the *Company of Parish-Clerks of* London. *&c*

LONDON:

Printed and are to be sold by E. *Cotes* living in *Aldersgate-street,* Printer to the said Company 1 6 6 5.

35. The figures for the Great Plague of 1665 were recorded in the weekly Bills of Mortality. The title page of the summary for the year has suitably macabre drawings. (Stephen Porter)

the Tower to the Temple along the riverside and as far inland as the city wall. The losses included 13,200 houses, St Paul's Cathedral, eighty-seven churches and six chapels, fifty-two livery company halls, the Custom House and the Royal Exchange, Blackwell Hall, three prisons, Bridewell and the Sessions House. The Guildhall was gutted. Between 65,000 and 80,000 Londoners were burned out and the value of the buildings, trade and household goods destroyed may have been almost £8 million. Even so, 80 per cent of the metropolis escaped untouched, and the homeless quickly found accommodation.

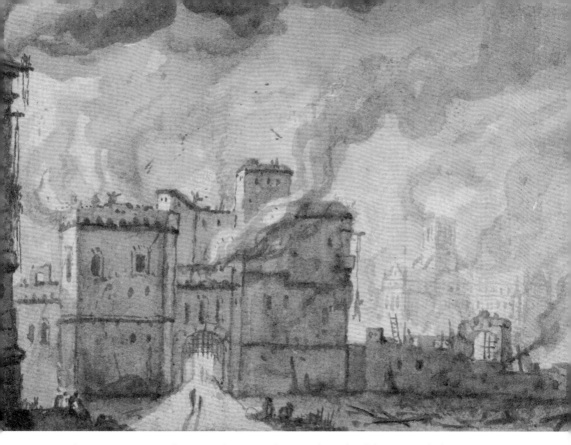

36. The Great Fire in early September 1666 destroyed much of the city, including Newgate, which is shown engulfed by flames in this drawing by Thomas Wyck. (Yale Center for British Art, Paul Mellon Fund)

The need to rebuild was urgent, but both the City and the government recognised that the reconstruction should be based upon the existing policy that new buildings were to be 'built with Brick or Stone, or both, and straight up, without butting or jetting out into the Street, Lane or place'. An Act of Parliament classified the new houses into four types, based on size. All of them were to have external walls of brick or stone, with roofs covered with tiles, and the party walls were to remain intact, ensuring the integrity of each house, for the interconnections between houses were one reason why the fire could not be halted. Some streets were widened, a new one was created leading from Guildhall and the marketplaces were resited, but imaginative plans to set out a wholly new street plan were impractical. A duty on coal landed in the port of London financed the public buildings and a fire court was set up to quickly settle ownership, liability and boundary issues, so that they would not delay the rebuilding.

Most of the new houses were built by 1672, although fewer were built than had been lost, with a reduction of perhaps 20 per cent. This was partly

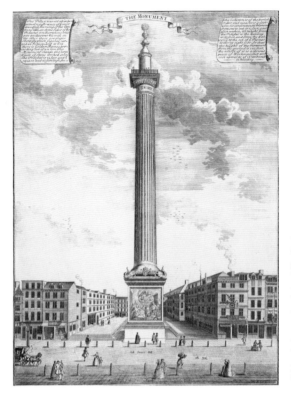

Left: 37. The Monument commemorates the Great Fire and stands close to the spot where it began. This drawing is by Sutton Nichols. (Yale Center for British Art, Paul Mellon Fund)

Below: 38. The old Temple Bar was replaced by this new structure in 1672, erected to Sir Christopher Wren's designs. (Stephen Porter)

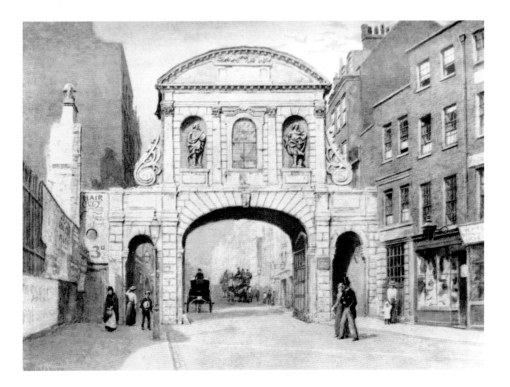

because the rebuilding regulations prohibited the erection of small dwellings in the back alleys and courts. The majority of the livery companies' halls were replaced by the late 1670s, together with the Royal Exchange, Custom House, Guildhall and other public buildings. To commemorate the fire a slender Doric column, dubbed the Monument, was built at the site where it had begun. The opportunity was taken to reduce the number of churches, with fifty-one rebuilt, all of which were in use by 1696, although some steeples and towers were added later, and St Paul's, begun in 1675, was not completed until 1710. Sir Christopher Wren was the architect for the cathedral and all of the churches.

The aristocracy and gentry had gradually been moving to fashionable new developments west of the City, a move that was stimulated, but not initiated, by the Great Fire. That trend produced a division, with retailers of high-value goods following their wealthy customers, while the merchants remained in the City. Covent Garden was set out on the Earl of Bedford's estate in the 1630s, with a licence authorising the building of houses for 'Gentlemen and men of abillity'. Similar developments followed, and squares and rectangular grid layouts became the favoured form of development in the growing West End, with the release of aristocratic and gentry estates on building leases; the

39. Sir Christopher Wren designed the city churches that were rebuilt after the Great Fire, and St Paul's Cathedral. This depiction from the river is by Thomas Shepherd. (Stephen Porter)

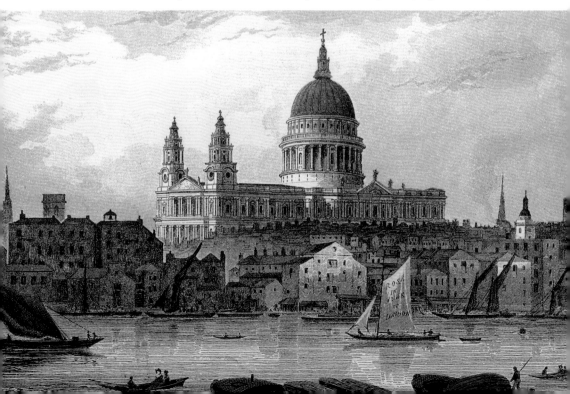

landlords retained ownership and the leaseholders undertook the building, on the security of a long lease and in accordance with its stipulations. The most prominent developer of the period was Nicholas Barbon, who operated on a large scale. His methods were copied by other developers and the face of London was gradually transformed through their projects, the building regulations and a change in taste which demanded buildings in brick and stone with a symmetrical appearance.

As well as the fabric, the political atmosphere was changing, for although the restoration of the monarchy was welcomed by enthusiastic crowds in 1660, Charles II's reign was marked by intermittent partisan strife, played out in Guildhall and on the streets. It saw the emergence of two groupings, not yet formal parties, dubbed the Whigs and the Tories, which, in general terms, were supported by the merchants and the landed gentry respectively. The restoration of the Crown was, of course, accompanied by the re-establishment of the Church, which imposed penal measures on Nonconformists, but a substantial minority of Londoners nevertheless remained outside the Church of England. There were tumultuous riots and demonstrations during the Popish Plot scare of 1678–79 and the subsequent Exclusion Crisis, when leading Whig politicians attempted to remove Charles's Roman Catholic brother James, Duke of York, as heir to the throne. The king was able to ride out the storm and in the early 1680s his supporters came to power at Guildhall and he struck a blow at the City by withdrawing its charter.

James succeeded Charles unopposed in 1685 and pursued a policy favouring his co-religionists and Nonconformists, hoping that they would combine to neutralise the power of the Church of England. That provoked such opposition that in 1688 his son-in-law William of Orange was invited by a group of peers and the Bishop of London to intervene, which he did, accompanied by his Dutch army. James was deposed by this Glorious Revolution and William and his wife, James's daughter Mary, took the throne as joint monarchs. The political settlement which followed included the restoration of the City's charter and promised greater political stability.

With William's accession, Britain was inevitably drawn into his foreign policy, which was aimed at curbing the growing strength of Louis XIV's France. The war with France which began in 1689 was to last until 1697 and was very expensive; the cost could be met only by drawing extensively on the resources of the City's wealthy goldsmith-bankers and merchants. The solution was the creation of a joint-stock bank, the Bank of England, authorised by an Act of Parliament of 1694, by which the government received an initial loan of £1.2 million, the interest on which was to be paid from duties levied on shipping and alcohol. Other loans followed, on the security of parliamentary

40. Just before Christmas 1661 Samuel Pepys, Clerk of the Acts, or Secretary, to the Navy Board, met the High Master and Sur-master of St Paul's school outside his bookseller's shop in Paul's Churchyard, as depicted in this drawing by Ernest Shepard of the 1920s. (Stephen Porter)

taxation, not the credit of the Crown, and so the government was able to tap the wealth of the City as the early Stuarts had been unable to do. The bank could also deal in bullion and bills of exchange, and issue paper money. During the 1690s there was a great increase in the establishment of joint-stock companies and London attracted capital not only from within the country, but also from abroad. King William's War was a struggle financially, but the city's wealth, with the innovations in public finance, enabled the country to meet its unprecedentedly high costs and those of the War of the Spanish Succession, which began in 1701 and continued until 1713.

Trading in the stock of the Bank of England and joint-stock companies, investments in the government debt, especially through Exchequer Bills and lottery tickets, saw the emergence of 'brokers and stock-jobbers', who specialised in trading in stocks. They were mistrusted and in 1698 were expelled from the Royal Exchange, shifting their base to coffee houses in

Exchange Alley nearby. That was not an eccentric choice, for coffee houses were places where men met, to transact business, socialise and exchange news and gossip; they were also patronised by London's intellectuals and literati. The first coffee house in London was opened in 1652; by 1663 there were eighty-two of them in the City and by 1739 the number had risen to 551 in the whole of London. By 1658 Thomas Garraway's coffee house near to the Royal Exchange was selling tea as well as coffee; he may have been the first retailer of tea in England. Marine and fire insurance was another branch of business which developed during the later seventeenth century; shipping news and insurance was based at Edward Lloyd's coffee house, which he moved to Lombard Street in 1691.

The growing financial quarter around Cornhill also developed as a centre for publishing, printing and bookselling. The Restoration government had attempted to re-impose some control of publications through a Licensing Act of 1662 that banned all books deemed to be heretical or seditious, but licensing lapsed in 1695, bringing press censorship to an end. Within the next fifteen years around twenty newspapers appeared in London, including the first regular daily, the *Daily Courant*, in 1702.

41. Coffee houses rapidly established themselves as places for men to meet, after the introduction of the drink in the mid-seventeenth century. A rather genteel eighteenth-century coffee house is depicted here. (Stephen Porter)

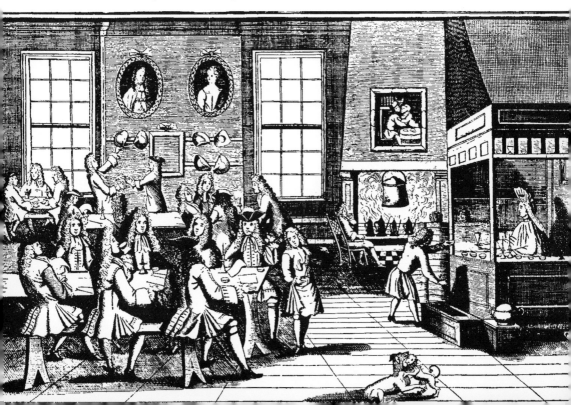

The theatres had been closed in 1642 and re-opened in 1660, with women acting on stage for the first time. A new repertoire was developed, including comedies which contrasted the bright and cunning rakehells of the West End with the worthy but naïve and plodding City men. Entertainment was enhanced with the first public concerts, established in 1672 by John Banister, a violinist, in the rather disreputable Whitefriars district, south of Fleet Street, although he moved them three years later to Covent Garden. Banister and others, including Henry Purcell, the foremost English composer of the seventeenth century, also composed for the theatres: more than fifty suites of theatre music were published in the first decade of the eighteenth century.

Political loyalties continued to be fiercely held, with the divisions reflecting those between the Church of England and the Nonconformists. But London was a tolerant city, absorbing immigrants, including the French Protestants (the Huguenots) after Louis XIV's revocation in 1685 of the Edict of Nantes, which had guaranteed them freedom of worship. By the end of the century 23,000 Huguenot refugees lived in London and the number of their congregations had increased from two to twenty-three. They mostly settled in Soho and Leicester Fields, and in Spitalfields, where they established a silk industry. The Jewish community continued to expand; a synagogue was built in Creechurch Lane and enlarged in 1674, before being replaced by a new building in Bevis Marks in 1700, and another, in Duke's Place, was erected in 1690, replaced in 1722 and again in 1788–90. London benefited significantly from the immigrants' skills and industriousness.

Georgian London

The period following George I's accession in 1714 was troubled by the Jacobite rebellion in 1715 and a financial crisis in 1720, when the price of South Sea Company stock rose to giddy heights before suddenly falling back. The company was an integral part of the public finances and so the bursting of the 'bubble' was a serious crisis, but it was skilfully managed by the Whig politician Sir Robert Walpole, who emerged as the first prime minister. He kept Britain at peace until the outbreak of war with Spain in 1739, dubbed the War of Jenkins's Ear, which soon merged into the more general War of the Austrian Succession. That was the first of five major wars with France and her various allies which continued with relatively short intervals of peace until 1815. They were fought in Europe and around the world, and from 1776 to 1782 in Britain's own colonies in North America as Britain engaged in a futile attempt to prevent them attaining independence. Their loss was offset by an increasing share of world trade, territorial gains and growing influence. As Britain's political and economic power developed, so London became the capital of an expanding worldwide empire.

It also played a dominant role in the British economy, drawing its provisions from every part of the kingdom. From the mid-eighteenth century the Industrial Revolution changed the economic structure, as manufacturing industries developed on the coalfields of the Midlands and the north of England. The cities in those areas grew rapidly, and the rise of the Atlantic economies benefited the west-coast ports of Bristol, Liverpool and Glasgow. But London continued to handle by far the largest share of overseas trade and remained the focus of the service sector and both cultural and political life. As the national population again began to grow, after a period of stagnation, the city continued to expand and had 960,000 inhabitants in 1801, the year of the first national census, and 1,655,000 by 1831. It had outstripped its rivals and become the world's largest city.

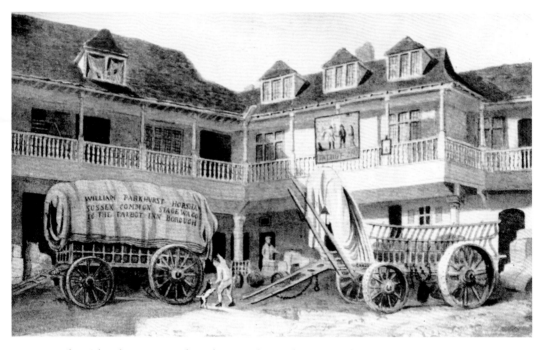

42. The Tabard Inn in Southwark was where Chaucer's pilgrims began their journey to Canterbury. The buildings were rebuilt after a fire in 1676 and renamed the Talbot; they were demolished in 1875–76. (Stephen Porter)

London's pattern of development established in the second half of the seventeenth century continued. The rectangular plans of the West End contrasted with the more erratic growth of east London, although some squares were also laid out there, while the riverfront was built up from the Tower to Limehouse. South of the Thames, development was stimulated by the building of Westminster Bridge (1750) and Blackfriars Bridge (1769), followed in the second decade of the nineteenth century by Vauxhall, Waterloo and Southwark bridges, while a new London Bridge was erected between 1823 and 1831 to replace the constricted medieval one. By 1800 only around 17 per cent of London's population lived in the City, and the trend continued as those who worked in the financial sector and the professions began to live elsewhere and commute in.

With the expansion of housing, a disparity developed between the number of inhabitants in some districts and the provision of places of worship. When the Tories came to power in 1710 they provided funds for fifty new churches, but just twelve were built. The early eighteenth century saw a growing apathy towards church attendance and indifference to organised religion, until the Methodist revival from the late 1730s, inspired by the preaching of the brothers John and Charles Wesley and George Whitefield. At first their

services were held in the open air, until a site in Moorfields was acquired for a chapel. John Wesley's preaching in particular drew thousands and so a new and larger chapel was opened there in 1778; it was described as the 'cathedral of Methodism'. The early nineteenth century saw a wider revival of attendance at services among both Nonconformists, with new chapels erected, and Anglicans, for whom new churches were built following the establishment in 1818 of the Church Building Commission. That produced a far more sustained programme of building than had its predecessor a century earlier, with over 120 churches erected in London and its immediate environs by the mid-1850s.

43. A burst of speculation produced the feverish activity of the South Sea Bubble in 1720. Fortunes were made and lost during the short-lived frenzy, depicted here. (Stephen Porter)

The most prominent new secular buildings in the City were the Mansion House, completed in 1753 as the lord mayor's official residence, and the Bank of England. The bank retained its monopoly of joint-stock banking and by the 1760s some 80 per cent of its business came through its connection with the government; almost all of its other transactions were within the city, so that it was known during the eighteenth century as 'the Bank of London'. Almost a third of the other bankers went out of business in the aftermath of the South Sea Bubble, but the sector recovered and there were fifty by 1770 and seventy by 1800. A new building for the Bank of England was erected in 1734 and subsequently enlarged. Britain's expenditure during the recurrent wars of the eighteenth century involved not only the costs of her own armed forces, but also the hiring of mercenaries and payment of subsidies to Continental allies. The national debt increased from £16.7 million in 1697 to £76.1 million by 1748, and by the close of the wars with France in 1815 it had reached almost £800 million. The bank's business grew correspondingly and a new building was erected in two phases, in 1793–95 and 1808–18. No other bank could match it. Indeed, although the first purpose-built private bank in the City was erected in 1757, by Asgill's in Lombard Street, until the early nineteenth century most banks were still in buildings used for both business and accommodation.

44. The frost fair on the Thames during the winter of 1788, as depicted by Samuel Collings. (Stephen Porter)

The royal palaces in London were also changing. Whitehall Palace was destroyed by fire in 1698 and Kensington Palace was built for William and Mary, beyond the West End. In addition, the court could use St James's Palace, Carlton House in Pall Mall, bought in 1732 for Frederick, Prince of Wales, and Buckingham House, which George III acquired in 1762 for Queen Charlotte and which became her favourite London residence. Somerset House had been built in the mid-sixteenth century and had served as a royal palace, chiefly for the queen consorts, but there was now little likelihood that it would be needed again, while the government had a pressing need for office accommodation. And so the Tudor palace was replaced by an office building, begun in 1776, which was both the largest public building project undertaken during the Georgian period and the first large purpose-built office building. It accommodated various government departments, including the Navy Office and the Stamp Office, and also housed the Royal Society, the Society of Antiquaries and the Royal Academy of Arts.

The foundation of the Royal Academy in 1768 marked a significant step in the emergence of art as a recognised profession. Its precursor was the St Martin's Lane Academy, founded in 1735 by the portrait painters John Ellys and William Hogarth, and almost all of its members were based in London. Born near Smithfield in 1697, Hogarth established himself as a portrait and history painter before attracting attention through his scenes of London life, with the engravings of his sets of paintings reaching a wide market. That was especially the case with those which he termed 'modern moral subjects', each set having a pictorial narrative. He satirised the well-to-do and the respectable, and drew attention to the plight of those who were exploited by the greedy and unprincipled, including girls forced into prostitution. While exaggerating for effect, Hogarth was expressing a contemporary impression of a wanton London and highlighting the harmful effects of cheap gin, which had become a very popular drink. Attempts to reduce consumption by raising the duty were made in 1729 and 1736, and the Gin Act of 1751 brought in tight licensing regulations. The measure was effective in reducing the number of dram-shops and alehouses, and the amount of gin produced fell by more than a third within a year.

The playwright and novelist Henry Fielding was prominent in the campaign to reduce gin consumption and in the control of crime. From 1748 he was the magistrate at Bow Street, where the earliest police office had been established in 1740, and was elected Chair of the Westminster Magistrates in 1749. He was succeeded in 1754 by his half-brother Sir John Fielding, known as the 'Blind Beak of Bow Street'. The Fielding brothers were well aware of the living conditions of the poor and drew attention to the

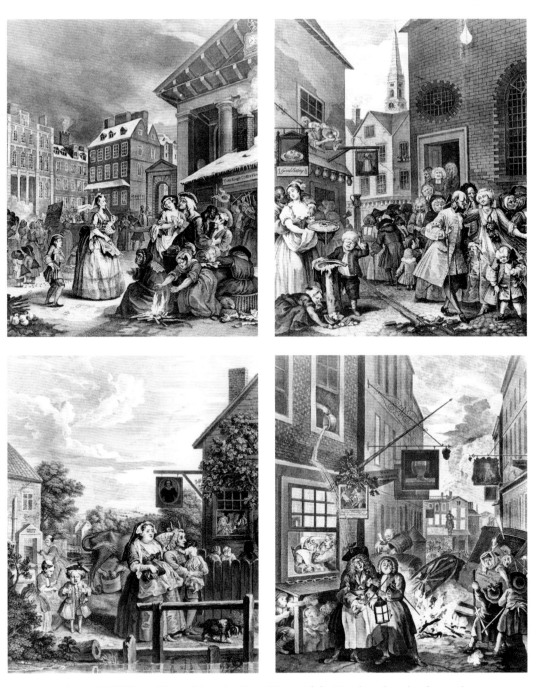

45, 46, 47, 48. William Hogarth's series *Four Times of the Day* has sharply observed scenes from London's street life and the interaction between the social classes. It was painted in 1736 and engraved in 1738. (Stephen Porter)

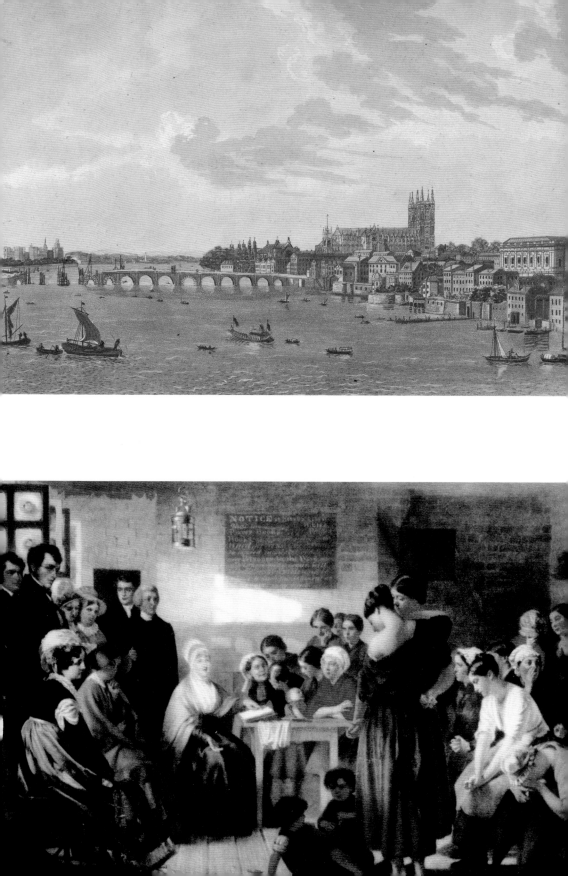

problems; they were equally energetic in enforcing the law and developed a reputation for their fairness in administering justice. In 1749 Henry created a force of six men to serve writs and make arrests; known as the Bow Street Runners, these were London's first police force.

Street patrols by the watch were among the responsibilities of the trustees or commissioners empowered by Act of Parliament to oversee paving, lighting and cleaning of the streets in a district. The first such body of commissioners was established in 1735 and by 1850 there were approximately 300 of them. They operated independently of the parishes, which continued to carry out their local government functions. From about the mid-eighteenth century, and especially after the first Westminster Paving Act was passed in 1762, a steady improvement could be seen. The street life and social conditions of early Georgian London, in the days when the infamous Jonathan Wild achieved considerable notoriety for his various criminal activities, had changed by the later part of the eighteenth century. But with the growing population and the increasing number of misdemeanours categorised as criminal, the prisons gradually became overcrowded and foul. They attracted the attention of reformers, especially John Howard and Elizabeth Fry, whose efforts were successful. But the Millbank Penitentiary, built according to their modern ideas, was not completed until 1821.

St Thomas's and St Bartholomew's hospitals were rebuilt in the early eighteenth century. At St Thomas's the new buildings contained twelve wards and 500 beds, and an operating theatre was built in 1791. Among its prominent benefactors were Thomas Frederick, Thomas Guy and Sir Robert Clayton, an immensely wealthy banker who served as lord mayor in 1679–80 and was described in 1720 as 'the largest and noblest of all modern Benefactors'. Guy surpassed even Clayton's donations, contributing to the new buildings at St Thomas's and also founding a new hospital close by which took his name. He had made a considerable fortune, initially as a bookseller, printing bibles for Oxford University, and later by selling his South Sea stock at a profit, before the price collapsed. His hospital opened in 1725 for those sick requiring long-term care who were not provided for at St Thomas's. The cost of the buildings and the endowment represented by far the largest example of private philanthropy in London at this time.

Opposite above: 49. The Thames looking upstream to Westminster and Westminster Bridge, which is under construction; it was opened in 1750. Engraved by W. M. Fellows, after Canaletto. (Yale Center for British Art, Paul Mellon Fund)

Opposite below: 50. The prison reformer Elizabeth Fry is shown reading the Bible to prisoners in Newgate in 1816. The painting is by Jerry Barrett. (Stephen Porter)

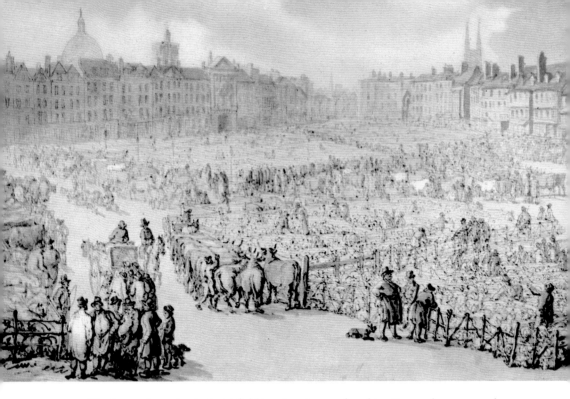

51. The livestock market in Smithfield in 1810; it was closed in 1855 and a meat market was then built there to Sir Horace Jones's designs and opened in 1868. (Stephen Porter)

Thomas Coram came from a very different background, for he was a seaman and shipbuilder. He established the Foundling Hospital in 1741 as the first institution in the country for unwanted boys and girls whose mothers were too poor to keep them, or deserted them out of shame because they were illegitimate. The charity followed the practices of a joint-stock company by raising money from subscribers, and initially no public funding was provided. Philanthropists were coming to prefer such hospitals and foundations to help the underprivileged, including the Magdalen Hospital for Penitent Prostitutes, a refuge which opened in 1758. There was, too, a growth in the number of charity schools, especially through the efforts of the Society for Promoting Christian Knowledge, founded in 1698, which taught girls as well as boys. Almshouses attracted less attention than in the preceding centuries, but continued to be founded. The royal establishments at Chelsea (1682) and Greenwich (1694) were restricted to retired and disabled servicemen. The livery companies made an increasing contribution to charitable giving, as their role in regulating trades declined. With growing charitable provision, a cleaner environment and improved healthcare, including a campaign of inoculation against smallpox, the overall death rate fell from the mid-century onwards.

Hogarth and other artists donated paintings to both St Bartholomew's and the Foundling Hospital, and the composer George Frederick Handel presented an organ for the Foundling Hospital chapel and organised very successful concerts there. Handel had arrived in London in 1710, one of the many musicians drawn to London as Italian opera became increasingly popular. When that waned, after the 1720s, Handel concentrated on the developing musical form of oratorio, based on biblical stories. Francesco Geminiani first arrived in London in 1714 and he also established himself as a composer and performer, organising concerts and publishing treatises on music. Performances of music by both Continental and English composers were held at subscription concerts and by musical societies in such varied settings as taverns and the livery companies' halls. Music reached a wider audience through being an integral part of theatre productions, intermixed with a play and other items on the same bill, and performances at the

52. John Gay's political satire *The Beggar's Opera* was first performed in 1728 and was a tremendously popular success. This painting is by William Hogarth and is dated 1729. (Yale Center for British Art, Paul Mellon Fund)

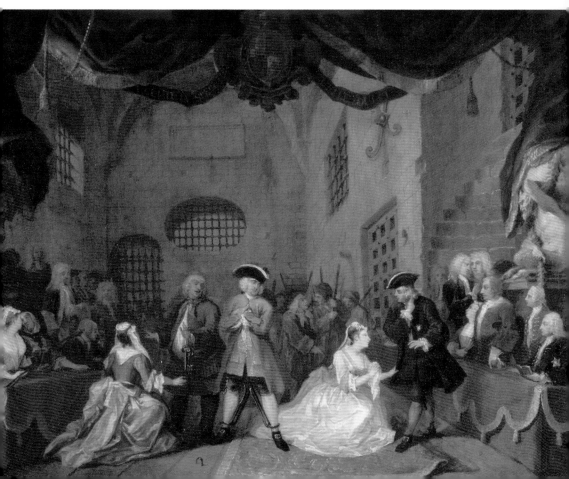

pleasure grounds, which drew large numbers of Londoners. The most fashionable ones were Vauxhall Gardens, known as Spring Garden until 1785, and Ranelagh at Chelsea, which opened in 1742.

The longest-running success in the theatre was John Gay's *The Beggar's Opera* (1728), a political satire and a counterblast to the current taste for Italianate music. The music was arranged by Johann Christoph Pepusch, a distinguished musical theorist as well as composer, who had come to England as a political refugee. He died at the Charterhouse, where he was the organist, in 1752. Handel died in 1759 and Geminiani in 1762, the year in which Johann Christian Bach arrived in London, where he soon took a leading role in the city's musical life. With Carl Friedrich Abel, who came to London in 1754, Bach set up the first subscription concerts in Soho, featuring their music and promoting that of other composers, including Joseph Haydn. Bach died in 1782 and Abel in 1787, but the music which they had fostered remained popular and Haydn made two triumphantly successful visits to London in the 1790s. Ballet became established in the repertoire after the success of John Weaver's *The Loves of Mars and Venus* at Drury Lane theatre in 1717, which employed mime and movement, without spoken or sung dialogue. In contrast, dancing, singing, scenery and impressive special effects were deployed to great effect in *The Necromancer: or, Harlequin Doctor Faustus* at the Lincoln's Inn Fields theatre in 1723, and its success established pantomime as a popular genre. During the middle years of the century David Garrick (1717–79) was the dominant figure in the theatre world. He was the foremost actor of his generation as well as a playwright, theatre manager and producer, and established many of the conventions and practices of the modern theatre. Not the least of his achievements was the appreciation of Shakespeare as the nation's greatest dramatist and poet. From 1785 until it was closed twenty years later, John Boydell's Shakespeare Gallery in Pall Mall sold engravings of scenes from the plays, from specially commissioned paintings.

Theatre performances were occasionally disrupted by some of the more rumbustious patrons, until the last such outburst in 1808. Street demonstrations also occurred from time to time, with a spell of protests in the 1760s in support of the radical politician John Wilkes and his right to take his seat in the House of Commons. Wilkes was also involved in City politics and a controversy in 1771 when the government tried to uphold the convention that press reporting of parliamentary debates was not permitted. Eventually the right to publish the debates was conceded, but not before the lord mayor, Brass Crosby, had been imprisoned in the Tower, the first lord mayor incarcerated there since the Civil War.

A far more serious and destructive outbreak, in terms of life and property, was the Gordon Riots in June 1780. The extension of Roman Catholics' civil rights

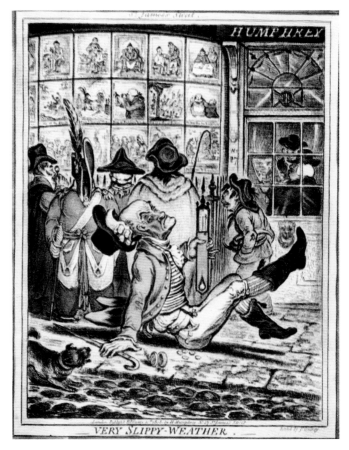

53. This gentleman is taking a tumble outside Mistress Humphrey's shop in St James's Street. She was the publisher of the caricaturist James Gillray, who issued this print in 1808; his prints adorn the shop's windows. (Stephen Porter)

in the Catholic Relief Act of 1778 had provoked strong opposition, expressed through the London Protestant Association and its vociferous president Lord George Gordon. A large crowd gathered in St George's Fields, Southwark, before making its way to Westminster to protest. Although the demonstrators moved off peaceably, a large-scale riot ensued and the property of Roman Catholics was wrecked, including chapels and schools, and the Sardinian embassy chapel close to Lincoln's Inn Fields. Newgate and the Fleet prisons, and the Clink and King's Bench prisons in Southwark, were set alight and the Sessions House in the Old Bailey was sacked. Groups of demonstrators attacked the Bank of England but were driven off by a detachment of soldiers. Less conspicuous buildings were also wrecked. After a week of mayhem the outbreak was crushed by troops. At least 285 people had been killed and a further twenty-five were hanged, although Gordon was acquitted when tried for high treason.

The association's objectives had been conservative, but other societies were aimed at promoting religious emancipation and parliamentary reform. Those goals were not attainable during the wars with France after 1793, or indeed

in the immediate post-war years. The wars brought some hardship, especially when trade with Continental Europe was curtailed during the Napoleonic Wars, but Britain's worldwide trade continued to expand and its merchant fleet doubled in size between 1786 and 1815. London's share of overseas trade had fallen during the eighteenth century to below two-thirds by value, but in absolute terms it had continued to increase in both value and volume. The number of vessels using the port that were engaged in overseas trade increased from 1,335 in 1705 to 1,682 in 1751 and to 3,663 in 1794, while the cargo tonnage rose more sharply, from 234,639 tons in 1751 to 620,845 in 1794, reflecting the increasing size of ships; the number of ships based in London that were over 200 tons rose from 205 in 1732 to 751 in 1794. Coastal trade doubled between 1750 and 1796, with shipments of coal increasing as the city's population rose. The river became so congested that docks were built in the first decade of the nineteenth century: the London Docks at Wapping, the West India docks on the Isle of Dogs and the East India Docks on the site of the East India Company's shipyard at Blackwall. St Katharine Docks were constructed close to the Tower in 1825–28. On the Surrey side the Commercial Docks were built in 1809 and the East Country Dock in 1811. Even so, the river remained overcrowded, as did the streets, a reflection of the city's thriving economy.

The imports and domestically produced goods fed London's consumer

54. The church of St Martin-in-the-Fields, built in 1721–26 to the designs of James Gibbs, is shown by Thomas Shepherd after the demolition of the buildings opposite in the 1830s, to create Trafalgar Square. (Stephen Porter)

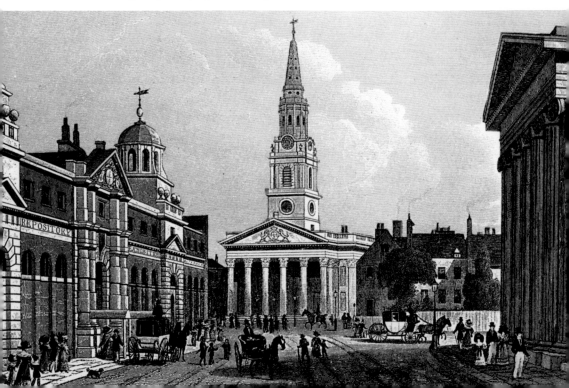

demand, which grew as the population expanded and the middle classes became more prosperous. Its shops impressed visitors, for the range of the items sold and their displays. The shopfronts could be transformed by plate-glass windows, available from the 1770s, although adopted only slowly. Cheapside, Fleet Street and the Strand remained the principal shopping streets. In the early eighteenth century the Strand contained 150 shops, including the premises opened in 1706 by Thomas Twining, who specialised in selling tea, the consumption of which increased enormously in the early eighteenth century. The newer shopping streets were Piccadilly, Bond Street and Oxford Street, which only gradually came to rival the existing thoroughfares, although by the 1830s Oxford Street had around 150 shops.

After the period of reaction from the 1790s, opposition to change eased during the 1820s. Political emancipation for Nonconformists came with the repeal of the Test Acts in 1828, followed by Catholic emancipation in 1829 and Jewish emancipation in 1835. Parliamentary reform was achieved with the Great Reform Act of 1832. Reform seemed to have been accepted, yet when University College was opened in Bloomsbury in 1828 as a non-denominational establishment, it was referred to as 'the godless institution of Gower Street'. The Anglican response was King's College,

55. Hyde Park Corner and the Wellington Arch, which was designed by Decimus Burton and erected in 1826–29. (Stephen Porter)

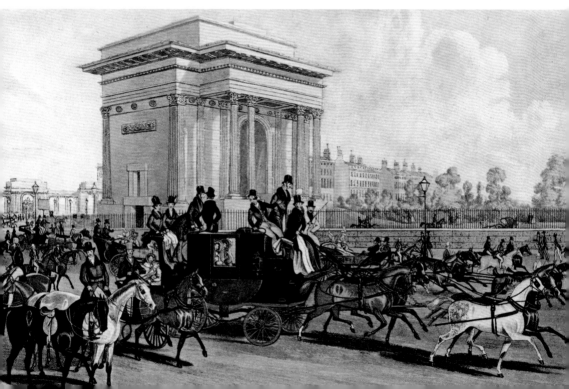

founded in the following year adjoining Somerset House. Denominational differences were eventually set aside, however, and both became constituent colleges of the University of London, which was granted a charter in 1836. The university added to the city's prestige and was to become widely influential in higher education, through its own achievements and those of its colleges in Britain and the Commonwealth.

56. Little Sanctuary in Westminster, 1808, engraved by J. T. Smith. The household items piled in the gutter suggest a house-move, or perhaps an eviction, from this shabby street. (Stephen Porter)

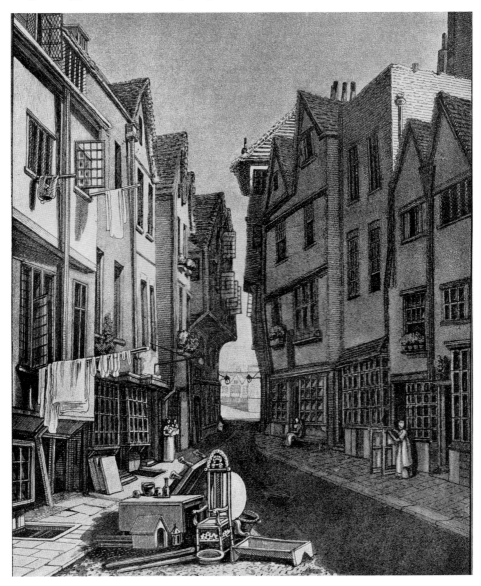

Victoria's Reign

Victorian London expanded dramatically, from a population of 2.239 million in 1841, the first census after the queen's accession in 1837, to 6.586 million in 1901, the year of her death. The national population also grew rapidly during the century, as did urbanisation, with the development of an increasing number of large cities both in the British Isles and Europe. The figures for London suggest a neatness of its boundaries which did not exist in reality. Without an administrative body for the metropolis there was a problem of defining its area, as its suburbs steadily expanded to absorb nearby villages. But while the outer areas increased their population, the numbers resident in the City fell, from almost 129,000 in 1801 to 27,000 a century later. Yet the corporation was resolutely unwilling to extend its authority beyond the City. The first body with responsibility for the metropolis was the Metropolitan Police, established by Sir Robert Peel in 1829, but its jurisdiction did not include the City. As elsewhere, responsibility for poor relief was transferred from the vestries to district boards of guardians following the Poor Law Amendment Act of 1834, but London was excluded from the other measures of the Whig governments during the 1830s, including the Municipal Corporations Act of 1835.

Pressure for reform came partly because of health hazards resulting from problems of water supply and the discharge of effluent. The appearance of cholera in 1832 and in subsequent outbreaks led to a campaign for centralised authorities to tackle the issue. The Metropolitan Commission of Sewers was established in 1848 and made some progress by covering open sewers, but met opposition to its plans for a system of main drainage. Cholera returned in 1849, causing 14,000 deaths in London, and again in 1854, and the all too evident foulness of the sewage-laden Thames showed that a stronger body was needed. In 1855 the Metropolitan Board of Works was created, with jurisdiction over much of the built-up area, but again excluding the City. Its plans to eradicate the noxious atmosphere which was believed to cause

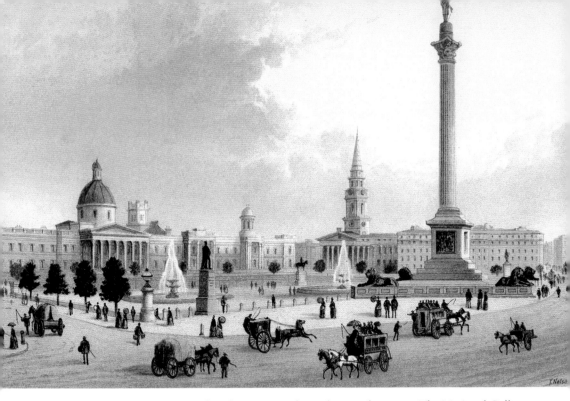

57. Trafalgar Square, created in the 1830s, is shown here in the 1880s. The National Gallery, on its north side, was opened in 1838 and Nelson's Column was completed in 1843. (Stephen Porter)

cholera were not implemented before the aptly named Great Stink in the hot summer of 1858 emphasised the urgency of the problem. In the following year the board accepted the proposal of its engineer, Joseph Bazalgette, for a system of sewers, with a main sewer along the north bank of the Thames which would intercept the effluent from the branch sewers running down to the river and carry it away from London to an outfall at Beckton. By that time pioneering work by Dr John Snow in Soho had indicated the causes of cholera, following an outbreak of the disease in the summer of 1854. He demonstrated that the disease was carried by polluted water supplies, not miasmic air emanating from insanitary conditions in overcrowded housing, as had been assumed. The final cholera epidemic in London was in 1866 and the sewer system was completed in 1875.

The Metropolitan Board of Works was assigned other functions, including the embanking of the Thames, street improvements and enforcement of building regulations, and in 1866 it took over responsibility for firefighting. But separate bodies were created to administer other matters, the Metropolitan Asylums Board (1867) and the School Board for London (1870), while the Port of London Sanitary Authority was assigned to the corporation (1872). Plans for local government reform in London were

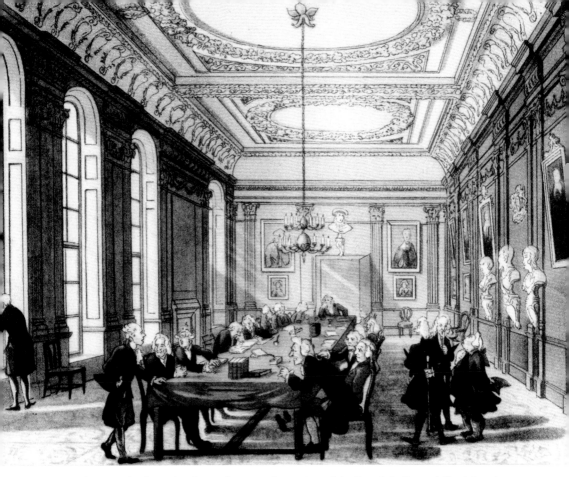

58. London was the focus for the professions. A meeting of the Royal College of Physicians in the early nineteenth century is depicted by Thomas Rowlandson and Augustus Charles Pugin. (Stephen Porter)

hampered by pressures resisting centralisation. Only with the passing of the Local Government Act of 1888 creating county councils in England and Wales was the impasse broken and the London County Council established, albeit with the boundaries of the Metropolitan Board of Works of thirty-three years earlier. Not until the London Government Act of 1899 were the lower-tier authorities reorganised, with the replacement of the vestries and district boards of works with twenty-eight boroughs. That was done not only as a necessary reform but also to provide local counterbalances to the LCC's centralising force.

Despite the lack of an overall administrative framework and the sluggishness of reform, improvements were carried out. The most striking change to the layout of early nineteenth-century London was initiated by the Prince Regent and implemented by his architect John Nash. From the prince's Carlton House in Pall Mall a broad new street, Regent Street, was set out to run north through new foci at Piccadilly Circus and Oxford Circus, on to

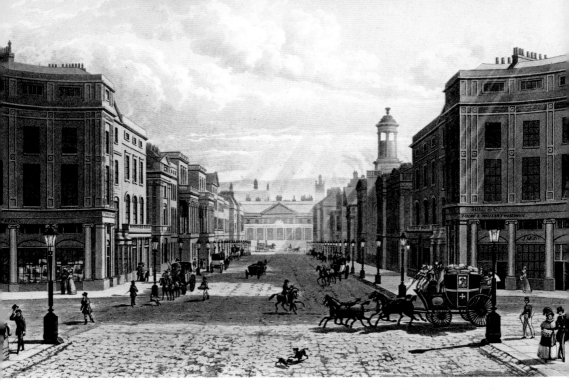

59. Regent Street was part of an ambitious piece of early nineteenth-century town planning designed by John Nash for the Prince Regent. (Stephen Porter)

Portland Place and then to Regent's Park. Nash's scheme envisaged another new street, from the south end of Regent Street to terminate opposite the façade of St Martin-in-the-Fields church. His plans for a square, or crescent, on that site were prepared in 1826, but not until the 1830s was the newly created space formed and designated Trafalgar Square, with the new National Gallery on its north side opened in 1838 and the column carrying Nelson's statue completed in 1843.

To the south of Trafalgar Square, Whitehall developed as the government's quarter, housing the offices of the Civil Service, which grew as government took on a greater range of functions domestically and as the empire expanded. The controversy over the choice of architectural styles for the new blocks south of Downing Street in the mid-nineteenth century was so fierce that it became known as the battle of the styles. An Italian classical design was eventually preferred to a rival gothic one. Yet the gothic revival plans of Sir Charles Barry and A. W. N. Pugin had been chosen for the new Palace of Westminster, to replace the Houses of Parliament, burnt down in October 1834. The palace was begun in 1840 and largely completed in 1860, with an impressive façade to the river and two tall and distinctive towers. Parliament Square was laid out in 1868.

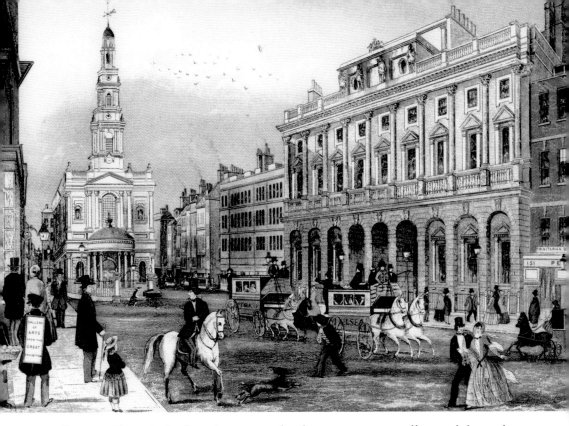

60. Somerset House in the Strand was erected to house government offices and those of learned societies; the church of St Mary le Strand was built in 1714–17. (Stephen Porter)

Gothic became the fashionable style of Victorian London, preferred for a range of buildings, from purpose-built banks and offices to public houses, and also for the other large-scale government building of the reign, the Royal Courts of Justice, erected between the Strand and Carey Street to G. E. Street's designs and completed in 1882. It was also chosen for the buildings of Albertopolis in South Kensington, erected on the initiative of Albert, the Prince Consort, from the profits of the Great Exhibition, which was held in Hyde Park in 1851. They included the Victoria and Albert Museum, the Natural History Museum and Imperial College.

The centre of the city, too, was transformed, by street improvements to ease traffic congestion and clear slum districts, and the erection of larger and more imposing edifices. New routes were created by the setting out of streets which cut across the existing pattern. Such new thoroughfares included the Victoria Embankment and the Albert Embankment, on opposite sides of the Thames. Victoria Street was set out in 1851 and on its south side London's first mansion flats were erected in 1853–54, in Ashley Place. Although initially regarded as being Continental in style, they became a popular type

of accommodation in London, with many such blocks erected in the late nineteenth and early twentieth centuries. Other streets were widened, to improve the flow of traffic, and so provided sites for new buildings.

Travel was also improved by the steamboat services and, more significantly, the coming of the railways from the late 1830s and underground lines from the 1860s. The railways provided long-distance travel at hitherto unknown speeds between London and the rest of the country, as well as supplies for its markets and suburban services for commuting, which became an increasingly common practice after the middle of the century. Those markets were also improved. By the early 1840s, 210,377 cattle and 1,650,448 sheep were sold annually at Smithfield, but in 1855 the livestock market was closed, greatly reducing the numbers of animals driven along the city's streets. Most railway lines ran to termini of varying size and grandeur around the fringe of the centre, but in 1866 the Southern Railway was extended across the river at Blackfriars and then to Farringdon, and the Metropolitan Line had been continued to Moorgate, allowing meat to be brought to Smithfield. The Central London Meat Market was built there in 1867–68. The corporation also rebuilt Leadenhall Market, in 1880–81, which specialised as a poultry market, while Covent Garden dealt mainly in market garden produce and flowers, which could now be brought in from a wider area. But Hungerford Market was suppressed when Charing Cross station was built on its site in 1864. Outside

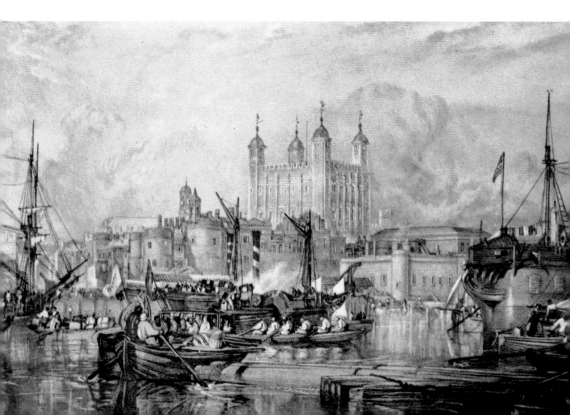

the station, in 1863 a replica Eleanor Cross was erected about 200 yards from the site of the original, built in 1291–94 and demolished in 1647.

The last railway terminus to be built, at Marylebone (1899), destroyed Blandford Square and Harewood Square, but many of the estimated 100,000 people displaced for railway construction between 1850 and 1900 had occupied poor housing. On the other hand, the improved communications provided by the suburban railways encouraged developers to build thousands of houses, mostly in straight, and often monotonously long, streets. The Victorians were very sensitive to the nuances of the social hierarchy and the appearance of the houses reflected that. The detached and semi-detached villas, with bay windows, some detailing and accommodation for at least one domestic servant, were aimed at the professional classes, the smaller semi-detached houses were designed for the growing number of white-collar workers and the better-off artisans, while the plain-fronted terraces were built for the 'lower classes'.

Beginning in 1886, Charles Booth, a wealthy businessman, carried out a survey of London that classified housing according to the perceived status

Opposite: 61. This watercolour by J. M. W. Turner from around 1824 depicts the first steamship on the Thames, and shows the river crowded with vessels. (Stephen Porter)

Right: 62. Two retired seamen from Greenwich Hospital are depicted by Sir John Millais visiting Lord Nelson's tomb in St Paul's Cathedral. (Stephen Porter)

of the occupants. His work revealed the extent of poverty, for he calculated that 30 per cent of Londoners lived on or below his 'poverty line'. Slum clearance became a policy objective. To replace the slums, model housing was constructed, typically blocks of flats. The American banker George Peabody established a model dwellings company, and its first block of dwellings, in Commercial Street, Spitalfields, was opened in 1864. By 1882 some 14,600 people were living in Peabody housing. But the philanthropic housing societies could not afford to build in districts where property values and rents were high, and so after the Housing of the Poor Act was passed in 1890 the new LCC began building model dwellings. That was the beginning of a policy of providing public housing, which both the county and the borough councils were to develop greatly in the twentieth century. As well as efforts to eradicate the worst housing, there was growing awareness of the predicament of the abject and homeless poor. For the homeless, soup kitchens and night shelters were provided by missionary movements, the most famous of which was the Salvation Army, founded in 1865 by William Booth.

The Poor Law was amended in 1834 to be administered by Poor Law Unions run by boards of guardians. Some London parishes were large enough

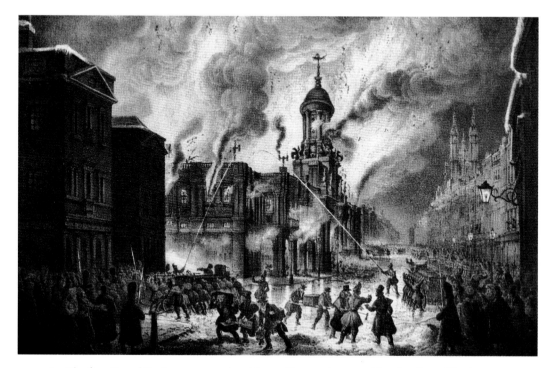

63. The first Royal Exchange, completed in 1568, was destroyed by the Great Fire in 1666 and the second was burnt down on 10 January 1838. Its replacement was completed in 1844. (Stephen Porter)

to constitute a union, and others were not drawn into the system until another Act of Parliament, in 1867. Under the arrangements, the workhouse system was greatly expanded. The objective was to keep the cost to the ratepayer as low as possible by creating unpleasant and degrading conditions which would deter those able and fit to work from claiming poor relief. Work of a harsh and monotonous kind was provided, for nothing could be produced which would compete with the output of commercial businesses. The forty union workhouses in London contained mostly children, the infirm and the elderly; their inmates were segregated by sex and so families were divided. In practice, the workhouse system was cruel, demeaning and socially divisive, and was strongly criticised by reformers, including Charles Dickens, who mentioned workhouses disparagingly in almost all of his novels, as well as in many of his other writings.

In the 1860s the deplorable state of workhouse infirmaries and pauper schools that educated thousands of orphans was exposed. The death rates within them were unacceptable and, following the establishment of the Metropolitan Asylums Board, the workhouse infirmaries were to develop as general hospitals. The nineteenth century also saw the establishment of specialist dispensaries and hospitals for infectious diseases, at least sixty-six of which had been founded by the 1860s. With the provision of hospitals, advances in medicine, cleaner water supplies and the solution to the problem of sewage disposal, the death rate in London by the end of the century was only slightly higher than the average for other urban areas. The treatment of orphans had improved, with the Poor Law unions generally sending them to local schools, which were rapidly erected across London by the School Board in a rather appealing Queen Anne style.

New prisons were built away from the centre of London and those within it were closed, including all the debtors' prisons. Wormwood Scrubs, Holloway, Pentonville and Brixton were built between 1820 and 1890, while ten prisons were closed during the same period, including those in Southwark. The Millbank Penitentiary was closed in 1890 (the Tate Gallery was built on its site) and Tothill Fields was demolished in 1885 and replaced by the Roman Catholic Westminster Cathedral.

The Chartist campaigner Ernest Jones was incarcerated in the Tothill Fields prison in 1848, when fear of insurrection was running high because of revolutions and protests on the Continent. In early March about 10,000 demonstrators took over Trafalgar Square and resisted police efforts to expel them; another rally was held in April on Kennington Common, and on 29 May a much larger crowd marched through the city to the square. Thereafter Chartism declined as a mass movement, but working-class radicalism continued. The First International Working Men's Association was formed in London in 1864 and the city contained more than a hundred working

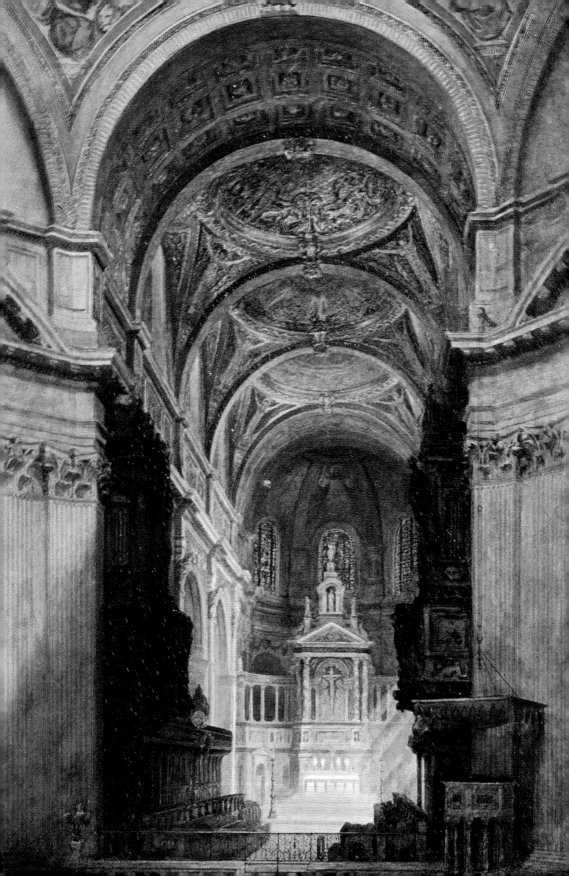

men's clubs. The Chartist demonstrations had shown that in creating Trafalgar Square the government had provided an ideal place for crowds to assemble, close to Whitehall and Westminster. On 30 July 1871 one of the largest crowds ever to gather in the square assembled there, despite a ban, to hear the republican MP Charles Bradlaugh speak critically of the monarchy, at a time when the queen was very unpopular.

During the mid-1880s an economic recession caused much hardship, and a protest rally of the unemployed was held in Trafalgar Square in February 1886. A section of the crowd broke away and rampaged through St James's and on to Piccadilly, before being dispersed in Mayfair. After that incident, designated 'the Pall Mall riot', the Home Office banned all meetings in the square and when a crowd of about 40,000 managed to gather there on 13 November, in defiance of the ban, it was confronted by 5,000 policemen, 200 Life Guards and a battalion of Grenadier Guards. They used strong methods, including fixed bayonets, to disperse the crowd, causing two deaths and hundreds of injuries on what came to be known as Bloody Sunday. The ban on public meetings in the square was not lifted until 1892.

But it did not require demonstrations to draw attention to the economic hardship, for many unemployed and homeless hung around the square, the most conspicuous location in London. Working-class protests were also expressed through strikes, two of which in 1889 attracted much attention and support. The first was by 700 women employed at Bryant & May's match factory at Bow, which was skilfully organised by Annie Besant, and the second was by dock workers in support of a claim for a 6*d*-per-hour wage increase, which became known as the 'Docker's Tanner'.

London continued to have a wide international trade and the number of ships entering the port roughly doubled between the mid-1790s and the early 1860s, although its share of Britain's trade declined as ports serving the industrial areas grew. Despite that relative decline, it still had 30 per cent of the country's overseas trade by value in 1913. London was also an industrial centre, containing 15 per cent of the manufacturing jobs in England and Wales, both craft-based in relatively small units and heavy industries on a factory scale. Clothing remained its largest industry and it expanded following the invention of the sewing machine in 1846 and the bandsaw (which made it possible to cut many cloths simultaneously) in 1858. It employed 30 per cent of the city's manufacturing workforce, while shoemaking employed 10 per cent. No one trade was dominant across the city, but some districts developed specialities, such as furniture-making in Shoreditch

Opposite: 64. A decorative scheme carried out in St Paul's during the 1890s included installing mosaic work to the vault of the choir. The work was designed by Sir William Richmond. This watercolour is by Edith James. (Stephen Porter)

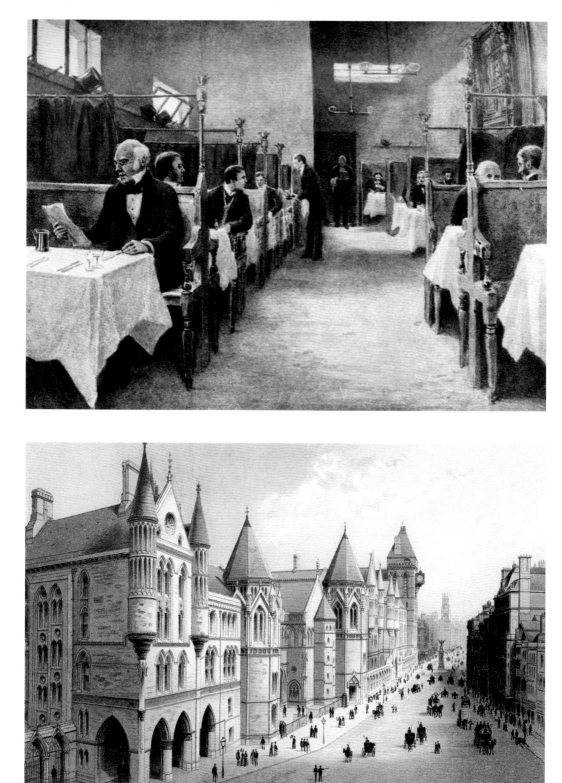

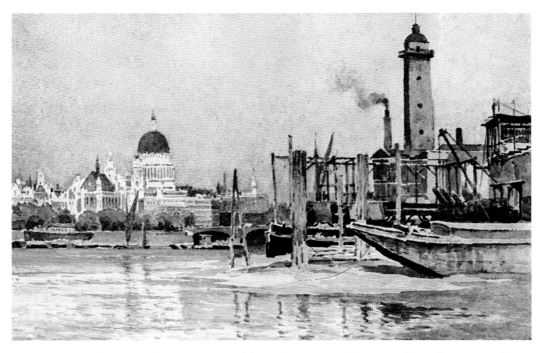

Opposite above: 65. The dining room of the Cock Tavern in Fleet Street shows the interior of a typical mid-nineteenth-century eating house, before its destruction in 1886. (Stephen Porter)

Opposite below: 66. The eastern section of the Strand, soon after the completion of the Royal Courts of Justice in 1882. (Stephen Porter)

Above: 67. E. W. Haslehust's painting of the Thames below Waterloo Bridge shows the contrast between London, on the far bank, and the industrialised river frontage of Southwark. (Stephen Porter)

and leather trades in Bermondsey, which accounted for 'the unpleasantness of the compound of horrible smells which pervade the whole neighbourhood', according to Charles Dickens's son (also named Charles).

The city contained the financial businesses to service the trade and industrial sectors, including the raising of the large amounts of capital required to build the railways. That was made easier by the repeal in 1825 of the Bubble Act of 1720, passed in the aftermath of the South Sea Bubble and requiring joint-stock companies to obtain a royal charter. The removal of that constraint on business was balanced by regulation contained in successive company acts and bankruptcy acts. The accountancy business developed in parallel with the growth of the financial sector, from twenty-four accounting firms in London in 1811 to 840 by 1883.

Although broadly based, the city's economy was subject to trade fluctuations and periodic financial crises, such as those in 1847–48 and in

68. The Grapes in Narrow Street, Limehouse, featured in Charles Dickens's novel *Our Mutual Friend* as the Six Jolly Fellowship Porters, 'a red-curtained tavern, that stood dropsically bulging over the causeway'. (Stephen Porter)

the 1860s. The financial crisis of 1867 dealt a blow to London's shipbuilding industry, the greatest achievement of which had been Isambard Kingdom Brunel's prodigious *Great Eastern*, built at Millwall as recently as 1854–59. Shipbuilding and marine engineering on the Thames employed 6,000 men in 1851 and 27,000 by 1865, but the number fell to 9,000 by 1871 and to 6,000 by 1891. New employment was provided on the river by the opening of further docks, the Victoria in 1855 and the Albert in 1880, serving the newly developed industrial districts of Canning Town, Silvertown and Beckton, and the Millwall Docks, opened on the Isle of Dogs in 1868. As with industry, trade fluctuations caused variations in business and so sharp competition among the dock and warehouse companies.

As industry expanded, especially along the Thames and in the East End, so social zoning was accentuated, with east London developing as a predominantly, although by no means exclusively, working-class and industrial area. Indeed, it became something of a fascination to Londoners from other parts of the capital, with a reputation for being poor, rough, unhealthy and unruly. In 1888 the barbarous Whitechapel Murders were committed. Six women were killed and mutilated by 'Jack the Ripper', the name appended to letters sent to the police. The crimes shocked late Victorian England and contributed to the area's

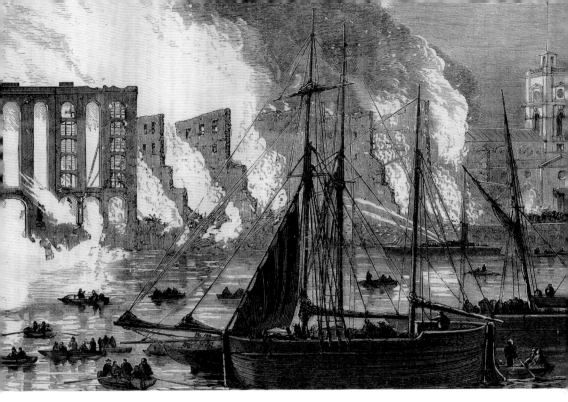

69. A fire in warehouses between Tooley Street, Southwark, and the Thames on 22 June 1861 destroyed twenty warehouses and their contents. The superintendent of the fire brigade, James Braidwood, and a colleague were killed. (Stephen Porter)

reputation, although at the same time they gave those working to alleviate the poverty the opportunity to publicise the real situation. The character of the East End was modified by the arrival in the last two decades of the century of Jewish immigrants from eastern Europe, fleeing from persecution. Ireland had been the most common source of migrants to London in the early part of the reign and 5 per cent of London's population was of Irish origin by 1851, and the Jews were the most numerous group in its later decades. The Jewish population of London rose from around 46,000 in 1881 to about 140,000 in 1905. They settled mainly in the East End, where many were engaged in the clothing trades. By 1901 roughly a third of the eastern European Jews in London worked in the industry, mostly in the local sweatshops, although there was also a strong domestic industry based on the putting-out system, in which workers took the articles or pieces home or to their own workshops.

London's housing and social problems were offset by growing prosperity and greater leisure, with new theatres, the emergence during the mid-century of the music hall and the opening of concert halls in Langham Place in 1893 and Wigmore Street in 1901. More buildings connected with national history, housing collections of art and sculpture, or having a literary

association were opened to the public, and new museums were established. This was largely in response to increasing demands for such buildings to be accessible to all, preferably free of charge, so that the growing educated working classes would not be deterred from visiting them.

Victoria's reign also saw an upsurge in popular spectator sports. Lord's Cricket Ground was established in 1814 and the pavilion dates from 1890; the Oval was opened as a cricket ground in 1846 and its pavilion was completed in 1897. Football clubs were formed in increasing numbers from the 1860s, including the Wanderers, founded in 1864 and based at the Oval. The first FA Cup final was played there in 1871, and it staged the final annually until it was transferred to the Crystal Place in 1895. For exhibitions, the Royal Agricultural Hall in Islington was opened in 1862 and the exhibition hall at Olympia in 1886. As the Great Exhibition had celebrated Britain's achievements in the mid-century, so Queen Victoria's Golden and Diamond Jubilees in 1887 and 1897 respectively, when her earlier popularity had been regained, provided the opportunity for celebrations. During her long reign London had become the capital of an empire that occupied a quarter of the globe.

Below left: 70. Visitors to Westminster Abbey during the nineteenth century described the interior as gloomy, but this illustration from the 1880s contradicts that impression. (Stephen Porter)

Below right: 71. A Salvation Army service in the East End, where William and Catherine Booth focused their efforts. (Stephen Porter)

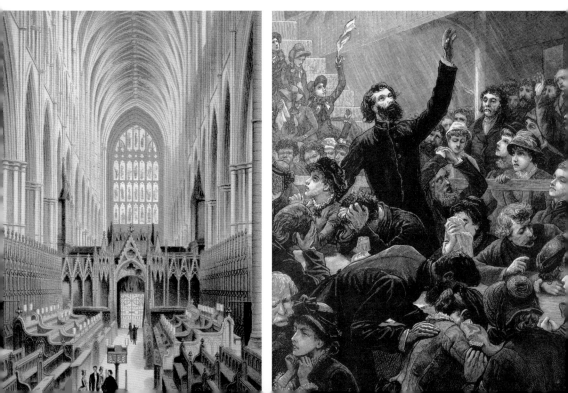

The Twentieth Century

Following Queen Victoria's death in 1901, a plan was prepared by the architect Sir Aston Webb for improvements to commemorate her reign. A large memorial was erected outside Buckingham Palace and The Mall was set out as a wide thoroughfare on a new alignment, with Admiralty Arch built at its eastern end, opening into Trafalgar Square. Buckingham Palace had been gradually enlarged, with a new wing facing St James's Park added by Edward Blore in the 1840s; that was now refaced by Webb. The work was largely completed by 1911. Admiralty Arch was both part of Victoria's memorial and an addition to the new government offices around Whitehall which were built in the early years of the century: the War Office and the Office of Woods and Forests in Whitehall and a large office block in Parliament Street.

Street improvements continued to be implemented, with the setting out by the LCC of the Aldwych and Kingsway, which cleared away several streets, widened the eastern section of the Strand and opened a new route northwards from Waterloo Bridge. Such improvements were justified by the need to ease traffic congestion. The nature of that traffic was altered by a major and remarkably swift change, as vehicles powered by the internal combustion engine replaced those drawn by horses. The removal of horse dung from the streets and stables ceased to be a problem and the provision of large quantities of hay was replaced by the need to make petrol supplies available. The first motor buses came into service in October 1899 and the number on the streets increased rapidly, from 241 in 1906 to almost 3,000 by the end of 1912. The last of the horse-drawn buses was withdrawn in August 1914. But congestion was not reduced by the change, as cabs, vans, lorries and cars increasingly came into use. The decade also saw the adoption of electric power for transport, with electric trams brought into service, especially after they were promoted by the LCC from 1903. They were ultimately to lose out to the buses, but the use of electric power on the

72. Admiralty Arch, designed by Sir Aston Webb and built in 1908–11, at the end of The Mall. (Stephen Porter)

underground system began with the opening of the Central Line in 1900, and electrification was completed by 1906. The extension of the network continued, with lines constructed beyond the central area.

Transport was just one of many aspects of London life to which the LCC was making a vigorous contribution. Its profile was further raised by the building of its new headquarters, County Hall, on the South Bank, begun in 1908. The smooth running of the city was nevertheless punctuated by dramatic events from time to time. In January 1911 Londoners' attention was briefly focused on Sidney Street, in the East End, where the police cornered members of a group of Latvian anarchists in a house. The gang exchanged fire with armed police and a detachment of Scots Guards from the Tower until the house caught fire and eventually collapsed. Inside were the bodies of two of the anarchists, but the others escaped. The incident attracted much attention, because the offenders were political refugees, they and the police used firearms, troops were deployed and the Home Secretary, Winston Churchill, had gone there during the siege.

Political agitation on London's streets in the years before the First World War was dominated by the campaigns of the Women's Social and Political

Union, which became the Militant Suffrage Society, to obtain equal political rights for women. In 1906 the suffragettes switched their centre of operations from Manchester to London and began a series of protests, which included invading the House of Commons, probably the first leaflet raid when a suffragette drifted over the Houses of Parliament in an airship painted with the words 'Votes for Women', the disruption of political meetings, the breaking of windows (including those of 10 Downing Street), vandalising government property, setting fire to pillar boxes, arson, letter bombs and disfiguring works of art, as well as demonstrations, marches and hunger strikes. The campaign was suspended after the outbreak of the First World War in August 1914, as the movement switched its energies to support the war effort.

London generally prospered during the war, for the great increase in government spending created many new jobs. With virtually full employment, the economy flourished and rationing was not introduced until 1918. Military purchasers replaced civilian ones, with a decline in demand for consumer goods and a fall in shipping using the docks, but a substantial rise in the output of clothing and leather goods, for example, to meet military requirements. Women replaced men who had joined the forces, and many took jobs in the greatly expanded munitions industry. Although those were not continued after the end of the conflict in 1918, by 1921 there were 950,000 women in the workforce. The adverse effects of the war were the loss of life among the forces, with approximately 124,000 Londoners killed on active service, and the deaths of civilians in air raids. Zeppelins launched eleven raids on the city, all of them at night, with the worst raid in June 1917 killing 160 people. As larger aeroplanes were developed, the Germans came to prefer them to the Zeppelins and those raids continued until May 1918. In total, 670 people were killed and 1,960 injured in the raids, which had scarcely any effect on the city's economy but made a strong impression on the citizens, for the new form of warfare, striking a civilian population apparently randomly, proved unsettling. And, just as the war was coming to a close, the worldwide influenza outbreak killed 18,000 Londoners during the autumn and winter of 1918/19.

The post-war period was one of economic and social readjustment; women were politically enfranchised, at last, but large numbers of returning service personnel had to be reintegrated into the economy. A boom in 1919 was followed by a slump in the following year, and problems of poor relief again came to the fore. To maintain their obligations to those in their borough requiring outdoor relief, the councillors at Poplar defied the government and refused to follow the procedure whereby the borough councils collected the rates for other authorities, including the LCC. Some of those councillors

73. Holywell Street, a centre of London's bookshops, was painted by Philp Norman in 1900, just before its demolition to make way for the Aldwych. The booksellers then decamped to Charing Cross Road. (Stephen Porter)

were imprisoned for a time, but in 1924 their case, which was labelled Poplarism, was upheld in the courts.

One of the major challenges was the continuing problem of slum clearance and the provision of good housing. Garden estates were built by the boroughs in the immediate aftermath of the war, known as Homes Fit for Heroes, and much larger schemes followed. The LCC had been granted powers to acquire land for building outside the county's boundaries in 1900. It now took full advantage of this and erected housing estates beyond the city, the largest being at Becontree and Dagenham, in Essex. In the 1930s it adapted its policy and also built houses and blocks of flats within the county. The boroughs also expanded their housebuilding programmes and continued to clear slums. Even so, overcrowded housing, multiple occupation and deficient sanitation remained problems in some districts into the second half of the century. The local authorities provided roughly 20 per cent of the housing erected in the twenty years after the First World War and private builders contributed the remainder of the 771,759 houses and flats built in and around the city. The term Greater London came into use to describe the expanded area of the metropolis. Extension of the tube lines encouraged that growth; the area of north-west London served by the Metropolitan Line from Baker Street was later dubbed Metro-Land. Streets of semi-detached houses predominated in the newly built areas, punctuated by parades of shops and a cinema. The number of cinemas in the county of London rose from ninety-four in 1911 to 258 in 1930 and continued to increase, compared with a fairly steady number of fewer than 100 theatres and music halls.

As the outer areas grew, so the population of inner London declined, as older houses were cleared and replaced by other buildings. The population of the City fell by two-thirds between 1919 and 1939. In Cripplegate housing was replaced by warehousing, the area around Mark Lane and Mincing Lane became 'honeycombed with vaults', and between 1860 and 1939 fifteen of the Wren churches erected after the Great Fire were demolished. The preservation of historic buildings, in the face of strong commercial pressures to rebuild on their sites, was an issue which was to continue throughout the century, as the conservation movement gathered momentum.

A part of the reason for the development of the outer areas from the mid-1930s was the dispersal of strategic industries, in anticipation of a war with Germany and the likelihood of devastating aerial bombardments. National Socialism made an impression in London in those years through the activities of Sir Oswald Mosley's British Union of Fascists, which engaged in anti-Semitic harassment. The most serious incident was its attempt to march through the East End on 4 October 1936, in a provocative demonstration

74. This view of
Oxford Street and
Winsley Street
was painted from
beneath Messrs
Gilbey's portico by
Yoshio Markino
around 1907.
(Stephen Porter)

directed at the Jewish communities there. A large crowd gathered and hastily constructed a barricade in Cable Street to prevent the marchers advancing into the East End, and they were successful. The clashes on that day became known as the Battle of Cable Street. The Public Order Act passed in the following December did much to prevent such provocative marches in future.

The Second World War began in September 1939 and continued for almost six years. Londoners had been prepared for war and its possible consequences, with a range of air-raid precautions put in place. The raids did not begin for a year, but the first one, on 7 September 1940, was followed by fifty-seven consecutive nights of bombing, and then a series of intensive

raids until May 1941. After that period, known as 'the Blitz', there were intermittent alarms until attacks by V-1 flying bombs began in June 1944, followed by V-2 rocket attacks in September, which continued until March 1945. In all, the city endured 354 raids by aircraft and 2,937 hits by pilotless bombs, with 29,890 people killed, 8,938 of them by the pilotless bombs, and 50,000 injured. The combined figure for those killed and injured was 54 per cent of the national total in air raids. In Greater London, 116,000 houses were destroyed and 288,000 were seriously damaged, with the East End suffering particularly badly. Significant historic buildings were lost, including eighteen City churches, seventeen livery company halls and parts of the Inns of Court, and among those badly damaged were the Houses of Parliament and the Charterhouse. The impact of the war was immense, not only because of the raids and their effects, which included homelessness and overcrowding, but also the evacuation of children, disruption of schooling, the redeployment of labour and the demands of the armed services, interruptions to supplies and hence shortages of food and materials, and a significant fall in population. Not all industries recovered, and the replacement of factories, workshops and housing took time, although the shortage of accommodation was ameliorated temporarily by the erection of prefabricated houses, affectionately known as prefabs.

Despite the problems of adjustment and shortages of materials and food, the post-war period was one of expanding trade and economic recovery. The optimism and aspirations of the time were expressed in the Festival of Britain, held on the South Bank in 1951 to mark the centenary of the Great Exhibition. The construction of the Royal Festival Hall marked the beginning of the long process of regenerating the South Bank.

Among the post-war measures was the Clean Air Act of 1956. Air pollution had a harmful impact during the centuries when coal was the predominant fuel, not least by causing intermittent dense and deadly fogs, and exacerbating respiratory diseases. Although it was some years before the Act took full effect, its implementation, with the steady replacement of coal as a fuel by electricity, oil and gas, slowly removed the worst pollution. The dark layers of sooty accretions on buildings could then be removed, so that they could at last be seen as their builders had seen them.

The various improvements were made against the background of the considerable challenges which the metropolis faced during the second half of the twentieth century. Its role as imperial capital and centre of world trade was swiftly lost as the United Kingdom's influence and the dominance of its currency waned, and as, within barely twenty years, the countries of the empire gained independence. This coincided with a period during which a new spirit of economic and political cooperation on the Continent saw the

creation and subsequent expansion of the Common Market. Britain's failure to join the original organisation gave other European cities the chance to get ahead as business centres, while London lost trade to such ports as Rotterdam and Dunkirk and, domestically, to Tilbury, Felixstowe and Dover. The closure of the docks along the Thames in the 1960s and 1970s signified the loss of the capital's seaborne trade, a key element in its economy for so long, and those years also saw a steep decline in its manufacturing industry, with the number of jobs in the sector falling by 80 per cent between 1961 and 1993.

Intervention by central government during the second half of the century included changes to London's local government. In 1964 the LCC was replaced by the Greater London Council, created as a strategic planning authority, also taking over the LCC's functions, but covering a much larger area intended to include the whole of the metropolis. At the same time, the boroughs created in 1899 were replaced by thirty-two new ones. But the GLC was abolished in 1986 and not replaced by a London-wide body. The Inner London Education Authority, which had been retained in 1964 within its existing boundaries, was also disbanded with the GLC.

75. A view along the Thames upstream from Tower Bridge in the mid-twentieth century; London's motor buses were described as 'the best means of seeing the externalities of the great city'. (Stephen Porter)

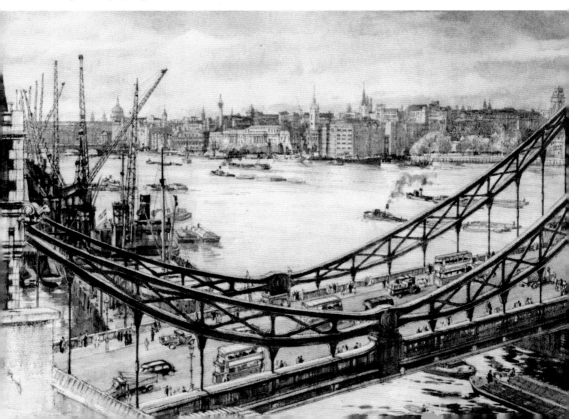

Government also intervened in the economic planning process, chiefly to curb London's growth, which was, once again, perceived to be inimical to the country's economy and society. Action included vigorous attempts to decentralise jobs, in both the Civil Service and the private sector. The Location of Office Bureau was created in 1963 to facilitate the movement of office jobs out of the capital, and it operated for almost twenty years. But Greater London's population was falling steadily and declined from more than 8 million to 6.8 million between the end of the Second World War and the mid-1980s, so that the planners were compelled to reconsider their approach.

Recognition of the deleterious effects of the changes in the dock areas along the river prompted the government to establish the London Dockland Development Corporation in 1981, with oversight of all planning matters and powers to acquire and dispose of land. Over the following years much of the area within its jurisdiction was redeveloped, along the north side of the Thames as far downstream as the royal docks and including the Surrey Docks on the south side. The most spectacular new development was at

76. The Charterhouse was badly damaged by bombing in the Second World War and was restored by the architects Seely & Paget in 1947–56. This painting of 1974 is by Hookway Cowles, a Brother of Charterhouse. (The Governors of Sutton's Hospital)

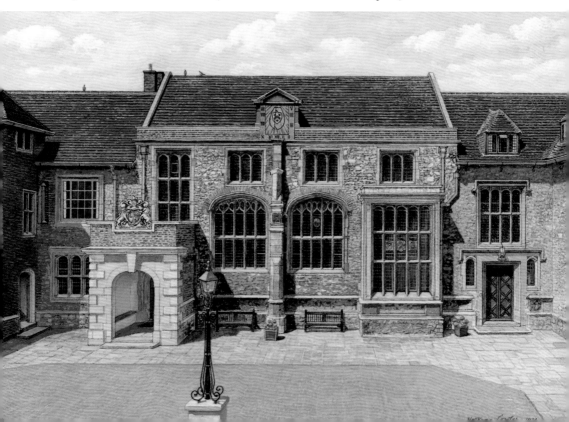

Canary Wharf on the northern part of the Isle of Dogs, which included a fifty-storey tower, completed in 1991; two further tall towers were built there ten years later. Canary Wharf was seen as a potential rival to the City as it developed into a major financial centre. The City's response was to relax its planning controls on high buildings and over the following years a number of tall structures were erected, giving central London a new and varied skyline.

Despite the changing context, domestically and across the world, London proved to be adaptable to meet the needs of the global economy, with the development of the City's financial services in particular, as well as other fields, such as communications, music, fashion, design, publishing and tourism. Districts which seemed to have been in irreversible decline were regenerated. London's economic supremacy within the United Kingdom was strengthened and it retained its political and cultural dominance. Its population decline was reversed before the end of the century, as it continued to attract and integrate newcomers, from the United Kingdom and overseas. When the Romans chose the site of Londinium they chose wisely and well, and their settlement on the north bank of the Thames grew to be one of the world's greatest and most resilient cities.

Acknowledgments

I am grateful to the Yale Center for British Art, the Society of Antiquaries of London, the Governors of Sutton's Hospital in Charterhouse and Jonathan Reeve for making their images available. My wife Carolyn has done wonders in finding material for the book, as well as providing her accustomed persistence and perception, tolerance and guidance.

London's History by Stephen Porter

'A meticulous recreation'
GILLIAN TINDALL
978-1-84868-200-9 £9.99

'A compelling, lively account'
BBC HISTORY MAGAZINE
978-1-4456-0980-5 £10.99

'A gem of a book'
RICHARD HOLMES
978-1-4456-0574-6 £12.9

'An insightful guide'
ALL ABOUT HISTORY
978-1-4456-0381-0 £20

'Brings London vividly to life'
SIMON JENKINS
978-1-4456-3274-2 £30

'An excellent introduction fo
the general reader'
THE SUNDAY TELEGRAPH
978-1-84868-087-6 £12.9